THE ART OF
Paint Pouring

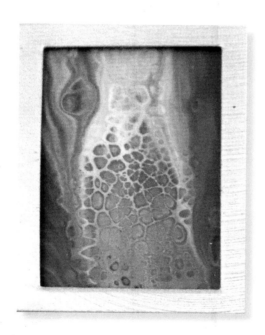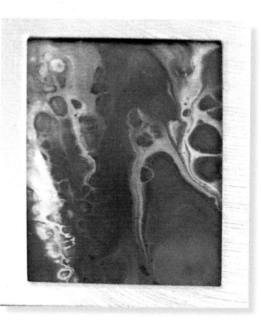

Amanda VanEver

Walter Foster

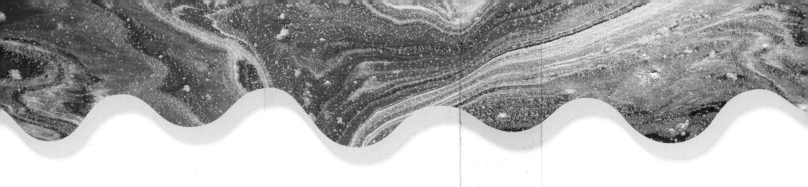

Brimming with creative inspiration, how-to projects, and useful information to enrich your everyday life, Quarto Knows is a favorite destination for those pursuing their interests and passions. Visit our site and dig deeper with our books into your area of interest: Quarto Creates, Quarto Cooks, Quarto Homes, Quarto Lives, Quarto Drives, Quarto Explores, Quarto Gifts, or Quarto Kids.

First published in 2019 by Walter Foster Publishing, an imprint of The Quarto Group. 26391 Crown Valley Parkway, Suite 220, Mission Viejo, CA 92691, USA.
T (949) 380-7510 F (949) 380-7575 **www.QuartoKnows.com**

Walter Foster Publishing titles are also available at discount for retail, wholesale, promotional, and bulk purchase. For details, contact the Special Sales Manager by email at specialsales@quarto.com or by mail at The Quarto Group, Attn: Special Sales Manager, 100 Cummings Center, Suite 265D, Beverly, MA 01915, USA.

ISBN: 978-1-63322-737-8

Digital edition published in 2019
eISBN: 978-1-63322-738-5

In-House Editor: Annika Geiger

Printed in China
10 9 8 7 6 5

Table of Contents

Introduction

When I was young, I never felt like I had any artistic skill or ability. Only in the last few years have I wanted to prove myself wrong.

When I first started seeing fluid, or poured, art online, I was instantly hooked. This abstract type of art features so many possibilities, and anyone can do it. Whether you're a beginner or an expert, there are many techniques and styles, and artists, myself included, are working to perfect them with our own unique flair.

This book will help you get started with the suggested supplies and simple techniques so that you can start, or expand on, your own paint pouring art journey. This book is by no means complete; there are many different variations and styles that you can find, practice, and create on your own.

Let's get started!

Tools and Materials

Here are the supplies you will need for paint pouring.

PAINTING SURFACES

Many surfaces can be used in paint pouring. For the main techniques demonstrated in this book, I've used canvas and wood surfaces.

CANVAS Canvas was the first surface I painted on. I practiced on basic, economically friendly canvases before trying out higher-quality and professional-grade canvases.

Canvases are sold online and in craft stores and come in different shapes, from squares and rectangles to ovals, circles, half-circles, triangles, and hexagons. I look online when I want a more unusual shape.

Canvases are available with gesso or primer preapplied, so they can be painted on immediately. Professional-grade canvases are sturdy and hold up well to the amount of paint required in fluid art.

IF YOUR CANVAS SAGS IN THE MIDDLE, SPRITZ THE BACK WITH WATER AND LET IT DRY TO TIGHTEN UP

WOOD I find my wood surfaces online, in craft stores, and in home-improvement stores.

I love wood for its versatility. You can buy precut shapes, or you may cut your own. You are not limited by a premade shape or size as with a canvas frame.

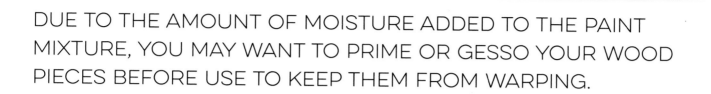

DUE TO THE AMOUNT OF MOISTURE ADDED TO THE PAINT MIXTURE, YOU MAY WANT TO PRIME OR GESSO YOUR WOOD PIECES BEFORE USE TO KEEP THEM FROM WARPING.

Craft stores and online retailers carry wood pieces that can be used for various painting projects. Small, thin pieces can be painted on and used to embellish larger pieces of art, bookmarks, holiday ornaments, magnets, and greeting cards. Larger pieces can be used to make beautiful handmade signs and clocks.

Unlike canvas, which can sag, wood doesn't warp when finished with resin.

OTHER SURFACES Wood and canvas are just two of the surfaces that can be poured on. You can also use many household items in your art. For example, paper can be poured on and used to make handmade cards and bookmarks. Pots and vases can be painted to liven up your garden or table, and even furniture can be poured on and sealed to brighten your living space. See pages 104-127 for instructions for painting on alternative surfaces, from coasters to magnets.

PAINT

Paint pouring is done with acrylic paints and acrylic inks. There are many brands to choose from, but you can use whatever is available in your area. Craft stores carry a wide selection of paint choices; however, if you have trouble finding certain brands or colors, online stores can help you expand your search.

When choosing paint, you will find a lot of information on each tube or jar. Every brand has its own method or representation of brand name, color name, color swatch, batch number, amount in the tube or jar, opacity, and lightfastness. It's helpful to know what the terms "opacity" and "lightfastness" mean so that can you select the best type of paint for your poured artwork.

Your intended use for your painting (whether you're just practicing or making a piece to sell) will determine the quality of paint that you want to use. If you are practicing, you can use less expensive craft or student-grade paints. If you are working on a more professional piece, you may want to use artist-grade paints so that your colors will stay bold and vibrant.

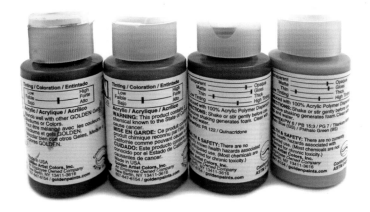

OPACITY A paint's opacity refers to how much coverage it provides. The more transparent the paint, the less coverage it will give you.

LIGHTFASTNESS A paint's lightfastness means that it will not discolor or fade due to light exposure. It is important to check your paint tubes for their lightfastness; this will help determine the quality of your finished artwork.

POURING MEDIUMS

Pouring mediums are added to create a thinner, more fluid paint for pouring art. Mixing too much water into your paint can cause the acrylic bonds to break, and over time your painting can crack or flake, ruining your art.

Pouring mediums keep those acrylic bonds intact. There are many brands available, and for a more cost-friendly resource, you can even use glue or decoupage sealer to extend your paint.

ADDITIVES

One element of poured artwork is cells, or the bubbles and patterns you see. To help form cells, you can use liquid silicone or dimethicone. Many household products containing these ingredients can be found online and in grocery, hardware, and big-box stores. I get good results using hair serums that contain dimethicone. Make sure that silicone or dimethicone is one of the top two or three items on the list of ingredients in whatever product you use for this purpose. For more on creating cells, see pages 22-27.

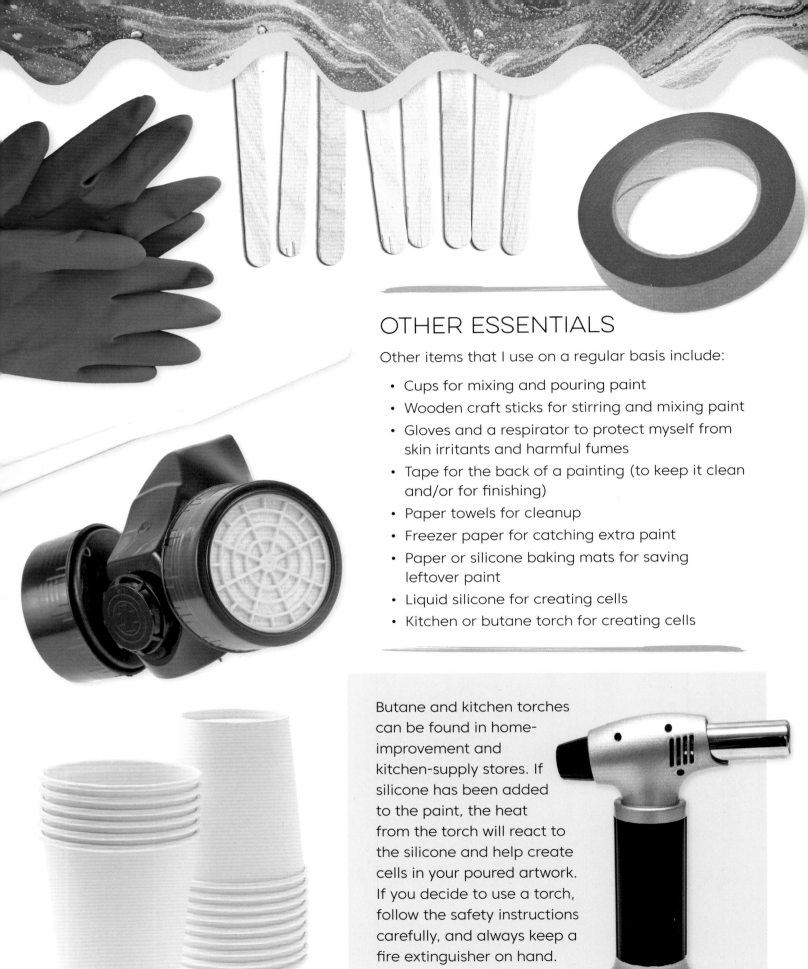

OTHER ESSENTIALS

Other items that I use on a regular basis include:

- Cups for mixing and pouring paint
- Wooden craft sticks for stirring and mixing paint
- Gloves and a respirator to protect myself from skin irritants and harmful fumes
- Tape for the back of a painting (to keep it clean and/or for finishing)
- Paper towels for cleanup
- Freezer paper for catching extra paint
- Paper or silicone baking mats for saving leftover paint
- Liquid silicone for creating cells
- Kitchen or butane torch for creating cells

Butane and kitchen torches can be found in home-improvement and kitchen-supply stores. If silicone has been added to the paint, the heat from the torch will react to the silicone and help create cells in your poured artwork. If you decide to use a torch, follow the safety instructions carefully, and always keep a fire extinguisher on hand.

REDUCE, REUSE, RECYCLE

If you wish to reuse or recycle items, you can let paint dry in a cup, and then peel out the dried paint to reuse the cup. Other items that can be used for pouring and storing paint include lunch-meat containers, yogurt cups, margarine or butter tubs, glass jars, and condiment bottles. Check out secondhand stores, dollar stores, and garage sales to find supplies to use or reuse in your paint pouring.

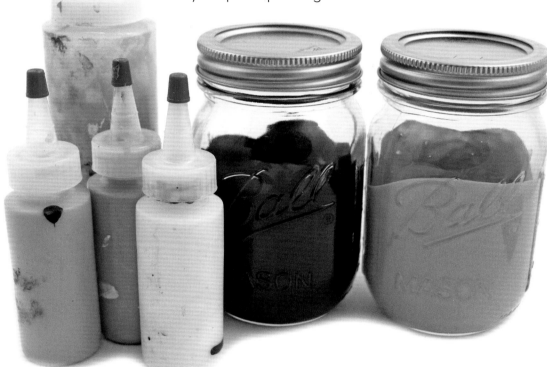

Safety Concerns

I use some materials in ways that are not intended by the manufacturer. Some items can have harmful fumes and may cause eye or skin irritation. Always wear protective gear like gloves and a respirator. Keep a fire extinguisher near your work area, and make sure the area is well-ventilated.

Use soap and water to remove acrylic paint from your skin. Rubbing alcohol can be used to remove resin.

Review all instructions and manufacturer warnings before using each product.

Color Basics

Understanding basic color theory is important no matter what kind of art you create. Color plays a significant role in the overall mood or feel of a painting, as colors and combinations of them can elicit various emotions in viewers.

Understanding how colors mix and interact with each other will also help you choose complementary color palettes for your poured paintings.

Let's start by learning about the color wheel.

COLOR WHEEL

The color wheel is used to demonstrate the relationships between colors.

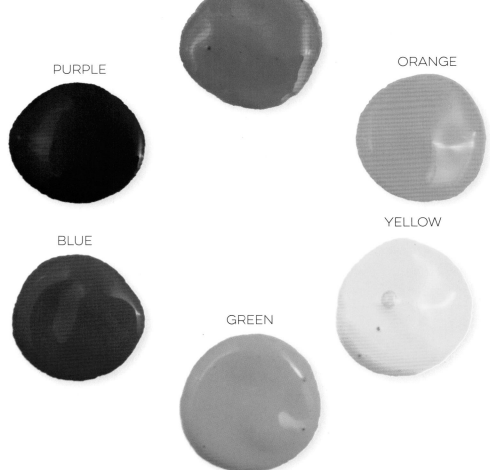

RED

ORANGE

PURPLE

YELLOW

BLUE

GREEN

PRIMARY & SECONDARY COLORS

The *primary colors* are red, yellow, and blue. They are the basis for all other colors on the color wheel and cannot be created by mixing other colors.

By mixing the primary colors, you can create green, orange, and purple, or the *secondary colors*.

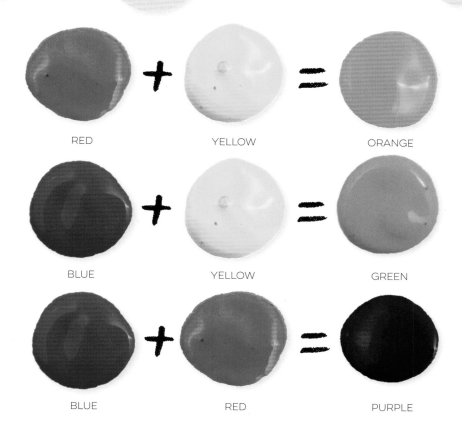

RED + YELLOW = ORANGE

BLUE + YELLOW = GREEN

BLUE + RED = PURPLE

RED + GREEN = BROWN

PURPLE + GREEN = BLACK

RED + PURPLE = BROWN

When mixing secondary colors, the results can become muddy. Keep this in mind when choosing colors for your poured art. You can mix secondary colors, but if the paint is too thin or if you overmix, the final piece can turn muddy and you may lose your original colors.

TERTIARY COLORS

Mixing primary and secondary colors together will create *tertiary colors*. These include the "in-between" colors like yellow-orange, blue-green, and red-purple.

SAMPLE COLOR PALETTES

I paint with a wide variety of color palettes, and below I've listed some of my favorites. Most of them include one metallic shade; I love the pop of color and shimmer that metallics give to a finished piece.

Remember that these are just suggestions. You should feel free to mix and match your own color palettes, and try mixing paints to create your own shades as well.

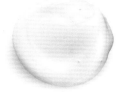

BLACK, GOLD, AND WHITE COPPER, TURQUOISE, AND PURPLE

PRUSSIAN BLUE, LIGHT BLUE, COPPER, AND WHITE

RED, ORANGE, YELLOW, GREEN, BLUE, AND PURPLE

PURPLE, DARK BLUE, LIGHT BLUE, AND GREEN

PURPLE, PEWTER, AND WHITE

BLACK, ROSE GOLD, AND LIGHT ROSE GOLD

RED/MAGENTA, PEACH, BROWN, AND WHITE

MAGENTA, GOLD, AND WHITE

BROWN, PEWTER, GRAY-BLUE, AND WHITE

Mixing Paint

Mixing paint with water and pouring medium is an important step in the paint-pouring process. It can take a bit of practice to get the consistency right every time you pour, however. Moreover, I find that I prefer different consistencies depending on the technique I'm using. For instance, if I'm looking for a striated effect (see page 86), I keep my paint thicker so that it doesn't mix too much. When I want my colors to blend, I make the paint thinner.

WHEN MIXING PAINT, IF YOU ACCIDENTALLY ADD TOO MUCH WATER AND CREATE A THINNER CONSISTENCY THAN YOU'D LIKE, ADD MORE PAINT AND MEDIUM UNTIL THE PAINT REACHES YOUR DESIRED CONSISTENCY.

As part of your learning process, try pouring with paint that is thinner or thicker than what you would normally use and see how the results turn out. From there, you can practice and tweak your mixture until you are happy with it.

IF LUMPS FORM AFTER MIXING THE PAINT AND THE MEDIUM, DON'T ADD WATER. KEEP MIXING UNTIL THE LUMPS DISAPPEAR. ADDING WATER TOO SOON WILL MAKE IT MORE DIFFICULT TO WORK OUT THE LUMPS OF PAINT.

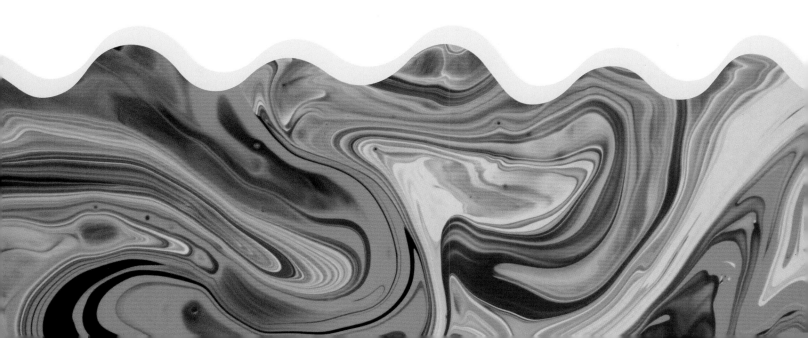

TYPES OF PAINT & MIXING PROPERTIES

I briefly mentioned paint on page 8, but now let's discuss it in more detail. I'll go over the benefits and downsides of various types of paint, as well as the effects and techniques that you can create with each type.

HEAVY BODY ACRYLIC PAINTS A professional grade of acrylic paint with a consistency similar to oil paint, heavy body paints can be used to create texture and an impasto effect (see below). You can mix heavy body paints with any pouring medium, but because of their dense viscosity, it may take more time to mix and work out the lumps to create a consistency that's suitable for pouring.

THE IMPASTO TECHNIQUE FEATURES A LAYER OF PAINT THICK ENOUGH TO ALLOW BRUSHSTROKES AND PALETTE KNIFE STROKES TO REMAIN VISIBLE.

MEDIUM BODY ACRYLIC PAINTS These student-grade, economically friendly paints are great for practicing pouring, and there are many brands to choose from. They feature a smooth viscosity and can easily be mixed with any pouring medium.

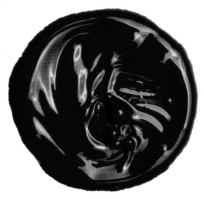

SOFT BODY ACRYLIC PAINTS With a smooth consistency and a large pigment load, soft body paints can be mixed into pouring mediums without forming lumps, and you only need a small amount.

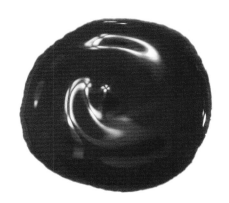

FLUID ACRYLICS These have a much thinner consistency than heavy, medium, and soft body paints. Designed to flow effortlessly, they are great for paint pouring and contain a large pigment load, so you only need a small amount to create a bold, vibrant piece of art.

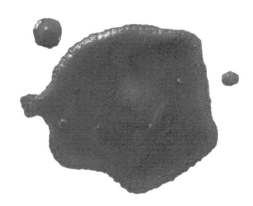

ACRYLIC INKS A fluid, acrylic-based medium, these inks can be added to any pouring medium and are used in the same way as regular acrylic paints. Because the pigment is very fine and they dry water-resistant, they can also be used in airbrushing, for stamping, and on fabric. They are great for adding embellishments, writing, or silhouettes to your poured pieces.

CRAFT PAINTS Like student-grade acrylics, craft paints are affordable, but they contain less pigment than student- and professional-grade paints. However, craft paints come in a large variety of colors, so you don't have to mix your own shades, and they feature a more fluid consistency that only requires a small amount of water or medium for pouring. Craft paints come in a variety of finishes, including matte, satin, gloss, metallic, chalk, and outdoor quality.

MIXING RATIOS

My own mixing ratio comes from trial and error. After lots of practice, I've found that mixing 1 part paint with 2 parts medium works well for me.

First, pour the paint. I've used about 1 ounce here.

Then add about 2 ounces of pouring medium.

Read the mixing instructions on your pouring medium. For soft body and fluid acrylics, the recommended ratio may be 1 part paint to 9 parts medium, due to the heavy pigment load in the paint. Once you've mixed your pouring medium with the paint, slowly add water and incorporate it into the mixture until it is thin enough to pour. This will require about 1 to 2 parts water, depending on how thick you want your mixture to be.

MANUFACTURED PAINTS CONSIST OF PIGMENT AND A BINDER, WHICH HOLDS THE PIGMENT TOGETHER. A HIGHER PIGMENT-TO-BINDER RATIO MEANS THAT LESS PAINT IS REQUIRED TO CREATE EVEN COVERAGE. HEAVY BODY, FLUID, AND SOFT BODY ACRYLICS FEATURE A HEAVY (LARGE OR SATURATED) PIGMENT LOAD, SO YOU'LL NEED LESS PAINT TO CREATE STRONG COLOR AND EVEN COVERAGE ON YOUR CANVAS.

Mix the pouring medium into the paint.

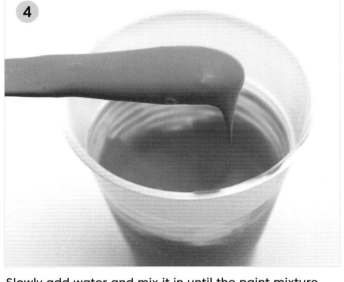

Slowly add water and mix it in until the paint mixture reaches the consistency that you want for pouring.

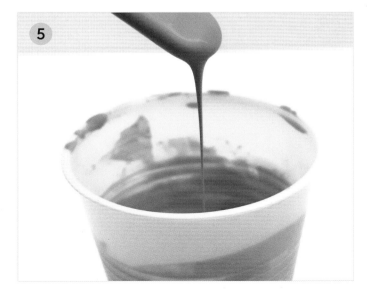

If you are using silicone or dimethicone to create cells in your poured artwork, you only need to add one or two drops to your paint mixture.

Creating Cells

The bubbles and patterns you see in poured artwork are called "cells." You can use a few products to create cells, including liquid silicone or dimethicone, rubbing alcohol, and Floetrol (pouring medium). Each product reacts differently to paint, so it will require some trial and error to discover how to make cells in your artwork, as well as which product(s) you prefer.

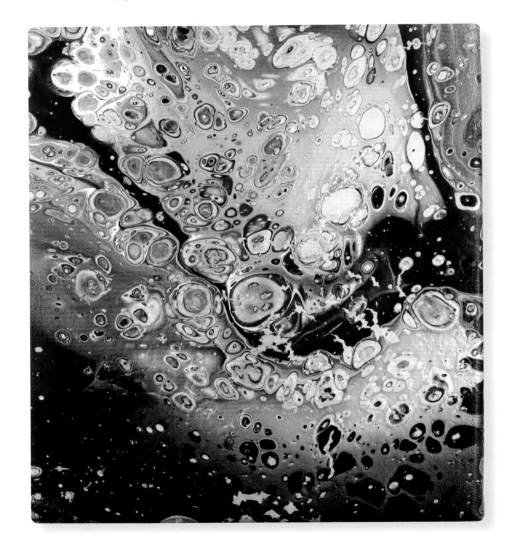

I use all of these products to create cells in my poured artwork, and over the next few pages, I'll show you how using the same color palette of black, gold, and metallic turquoise.

SILICONE/DIMETHICONE

One way to create cells—and in my opinion it's the easiest—is with liquid silicone or dimethicone, a type of silicone. These are included in many household and cosmetic products and are easy to find in stores or online. 100-percent liquid silicone is used for car maintenance and home improvement and repairs, and dimethicone can be found in hair oils and serums. Check the list of ingredients on a product, and make sure silicone or dimethicone ranks in the top two or three.

MAKE SURE TO USE LIQUID SILICONE; SILICONE CAULK WILL NOT WORK.

You only need to mix one or two drops of silicone or dimethicone into your paint mixtures. If you add too much, the paint may pull away from the canvas and form craters. Once the silicone or dimethicone is added to the paint mixture, use any paint pouring method you like, and then you can apply a torch either before or after tilting the canvas (see page 42 for more on tilting). Using a torch to heat the paint causes the silicone or dimethicone to react with the paint. This forms the cell structure commonly seen in fluid art.

Here I added one drop of silicone to my paint mixture. I used the flip cup technique (pages 44-49), tilted my canvas, and applied a torch to create a beautiful, cellular piece.

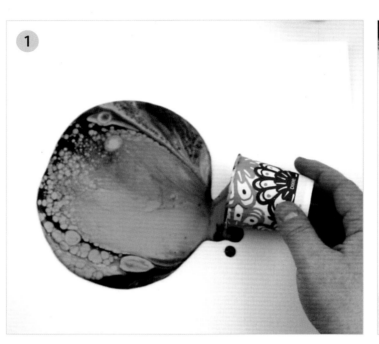

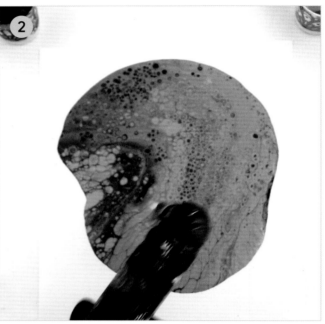

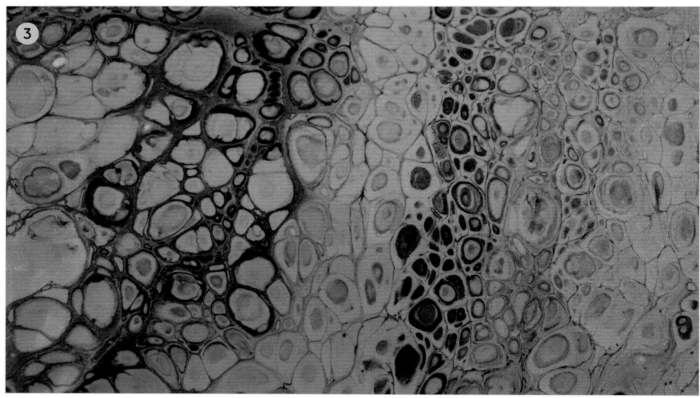

RUBBING ALCOHOL

Like silicone and dimethicone, rubbing alcohol can be used to create cells in poured artwork. In my opinion, cells don't form as easily with rubbing alcohol; however, because rubbing alcohol evaporates, you don't need to clean leftover residue from the canvas as you do with silicone (see page 29 for more information). To use, I simply substitute some of the added water in my paint mixture for alcohol.

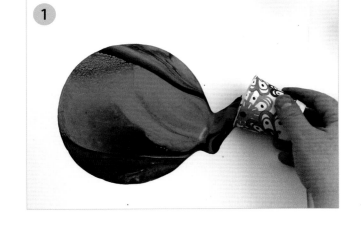

When using rubbing alcohol, prepare your paint mixtures, and pour them with any method that you like. Gently apply a torch, but be careful: Rubbing alcohol and its fumes are flammable! Always keep a fire extinguisher handy.

To create this artwork, I combined pouring medium, a small amount of water, and paint, and then, to thin the paint more, I added 1 or 2 teaspoons of rubbing alcohol. I again used the flip cup method. You can see that the cells are less defined than when I use silicone, but they still create a beautiful design!

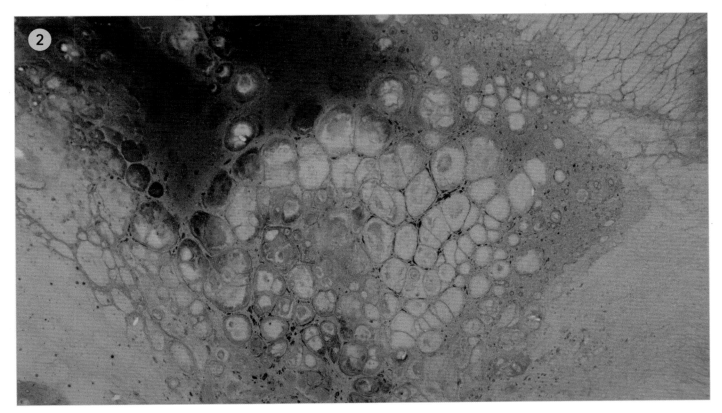

PAINT ADDITIVE

Paint additives (I use Floetrol) can be found online and at home-improvement stores in the paint department. They can produce cells in poured artwork even without the addition of silicone.

To use a paint additive to create cells, prepare your paint mixture and add Floetrol, following a ratio of 2 parts additive to 1 part paint. Mix in the paint, and then gradually add water until your paint mixture reaches the consistency that you want for pouring.

Here, I again used the flip cup technique (pages 44-49), and then I tilted the piece and torched it to create cells in my artwork.

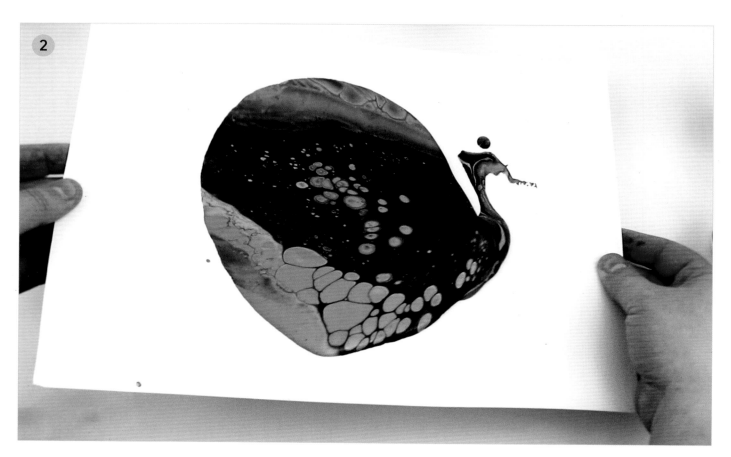

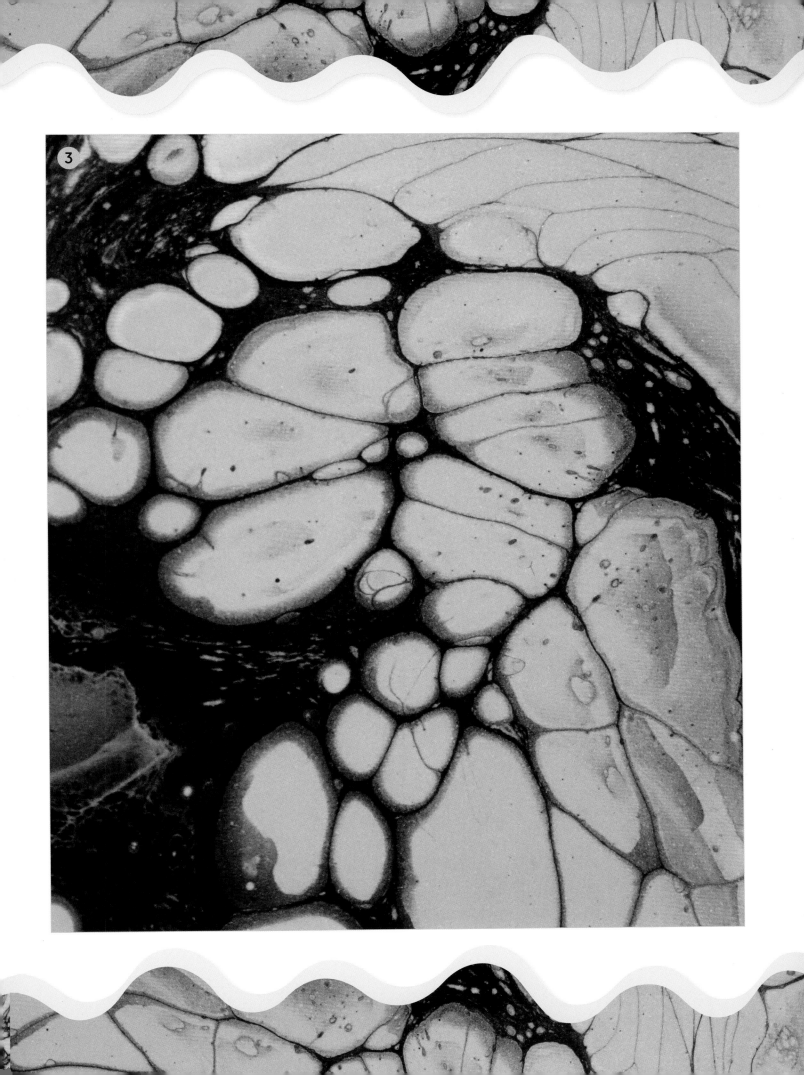

Finishing Artwork

The projects in this book start on page 38 and will show you how to use a variety of paint-pouring techniques to create beautiful, original artwork. It's also important to know how to finish and preserve your pieces, however. Here, I'll go over some tips and techniques for drying, cleaning, and finishing your fluid art.

DRYING

If you lay a wet piece on a surface that isn't flat, the paint can move and distort your design. The paint can even run off the canvas if the surface is tilted.

Whether you leave your painting on the cups on which you first painted it or move it to another location to dry, always check your surface with a level. If it isn't level, you can use small items to even out your surface. Even folding a piece of paper and placing it underneath your canvas can help create a level surface on which to dry your artwork.

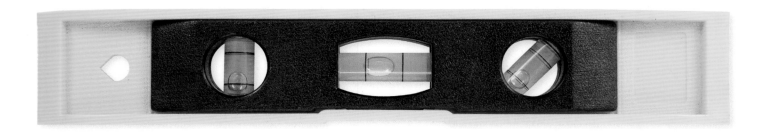

While drying your piece, you may also want to cover it to prevent hair and/or dust from landing in the wet paint. I have pets, and their hair has often gotten into my paintings. If you notice hair (or anything else) in your paint while it is still wet, you can use a toothpick to gently remove it.

Insects can also get into paintings, particularly if you work with your windows open or in a garage. To prevent this, drape a tarp over the table as your piece dries, or flip over a large plastic storage container to cover the table.

Many household items can be used or repurposed to cover your pieces as they dry. My husband helped me fashion mine, which is simply a shelving unit that we originally kept in the garage. We found a large piece of plastic to which we added a zipper using adhesive. Now I can place a painting on a shelf and zip up the plastic to form a makeshift enclosure.

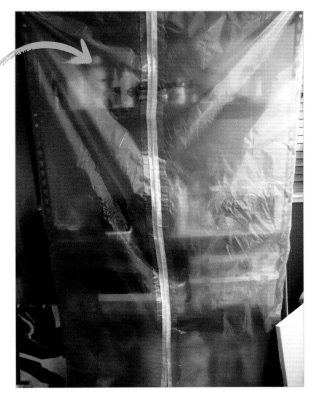

CLEANING OFF SILICONE

Before finishing your painting with varnish or resin (see pages 30-33), you will need to clean off the silicone if you added any to your paint mixture. The residue from the silicone can repel the varnish or resin, which will create pits or craters in finished pieces.

There are a few ways to remove silicone. I like to use rubbing alcohol and paper towels, but other options include a small amount of soap and water or a powder, like flour or cornstarch, that can be used to soak up the silicone.

Here's how I use rubbing alcohol to remove silicone from a fully dry painting.

Gently move the paper towel over the surface of the painting, including the edges. Some of the paint color may transfer onto the paper towel, but this shouldn't ruin the piece.

Then let the rubbing alcohol evaporate. Wait at least two hours before adding resin or varnish to your artwork.

Pour rubbing alcohol onto a piece of paper towel.

If you choose to use soap and water to remove the silicone from your artwork, dampen a paper towel or washcloth with soapy water, and gently apply it to your entire piece. Use clean water to wipe down your painting, and then let it dry.

Powders like cornstarch or flour can also be used to soak up silicone. Gently dust the surface of your painting, and let it sit for 5 to 10 minutes. Then use a paintbrush to dust off the powder, and wipe the painting with a damp paper towel to ensure that you've removed all of the flour.

PROTECTING PAINTINGS

After a fluid art piece dries, you can leave it as is, or you may want to finish and protect it with varnish or resin.

Varnish

Varnish comes as a liquid or a spray; both types are found online and at craft and home-improvement stores. Varnishes dry water-resistant without causing yellowing, and some can protect finished pieces from ultraviolet rays.

Varnishes come with different finishes, including gloss and matte. Varnishes with a gloss finish will create a shiny look and make the colors in your piece appear bold and vibrant. A matte finish creates a duller, more neutral finish without a shiny reflective surface, and the colors will look less vibrant. These are all important factors to consider when choosing what type of varnish to use.

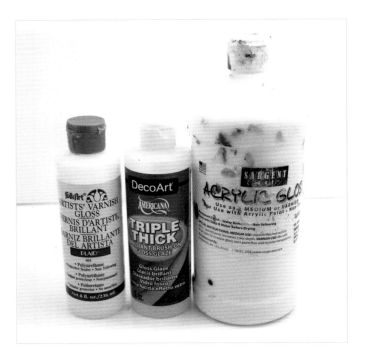

Liquid Varnishes

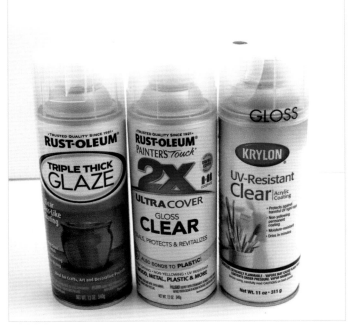

Spray Varnishes

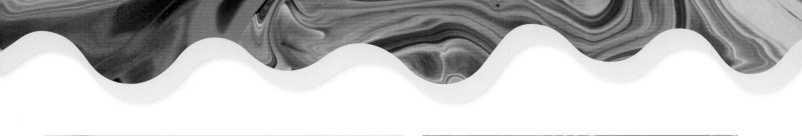

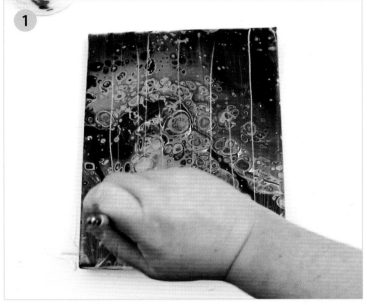

Before applying liquid varnish to a painting, clean off any silicone residue that remains on your canvas. Then pour a small amount of varnish onto the canvas, and use a paintbrush to evenly spread it. If the varnish is very thick, you can dilute it with a small amount of water, and then brush it onto the canvas.

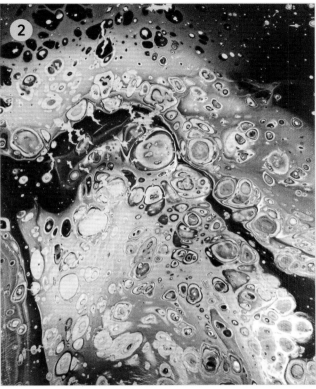

Let the varnish dry before displaying the painting.

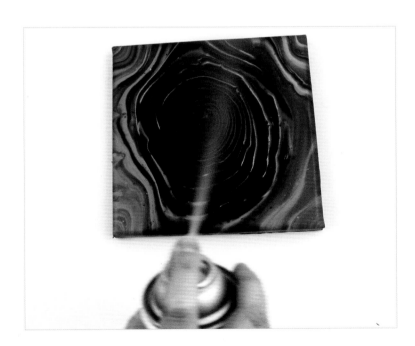

Spray varnish, which is applied like spray paint, is flammable, so make sure you work in a well-ventilated area, read the safety instructions before use, and have a fire extinguisher on hand. Rest your canvas on a flat surface, and then apply a thin layer over the entire piece. For even coverage, apply multiple light coats of varnish, instead of a single heavy coat.

Resin

For finishing a painting, my favorite product is epoxy resin, which creates a glasslike finish and makes the colors and details in a piece "pop." I use tabletop resin, as it's extremely durable, waterproof, and scratch-resistant, and it creates a protective surface. Resin can be found online and in craft and home-improvement stores.

Resin fumes can be toxic, so make sure to wear gloves, a respirator, and goggles. If you get resin on your skin, use rubbing alcohol to remove it. A kitchen torch can be used to remove the air bubbles created by resin.

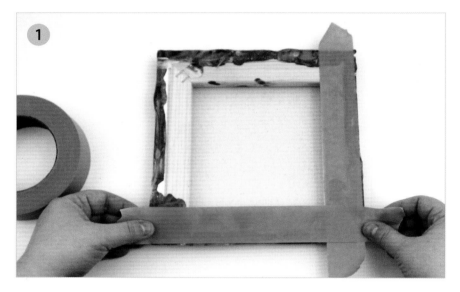

Before applying resin, set up your workspace (see page 38). Place tape on the back of the canvas and around the edges so that you can remove the tape and any hardened resin drips when you're done.

Then measure out equal parts resin to epoxy hardener, and mix them in a cup. Always follow the instructions on the resin, and make sure to mix for the correct amount of time. (Most resins must be mixed for at least 3 minutes.) Use the resin mixture before it hardens.

WHEN MIXING YOUR RESIN, YOU MAY NOTICE AIR BUBBLES FORMING. ONCE YOU POUR THE RESIN ONTO YOUR SURFACE, THE HEAT FROM THE TORCH WILL REMOVE THE BUBBLES.

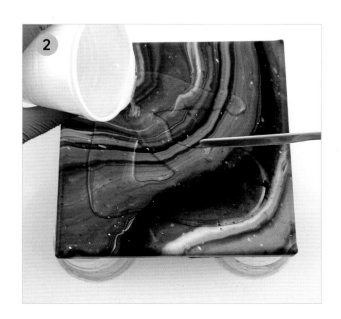

Next, pour the resin onto the painting. Tilt the canvas or use a stir stick to spread the resin for even coverage.

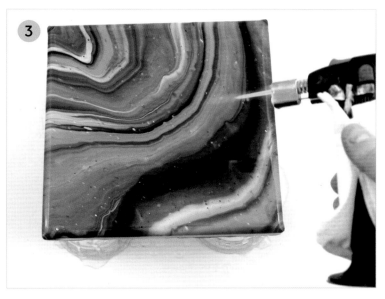

Apply a torch over the surface to remove any air bubbles. Don't keep the flame in one spot for too long, or you may burn the resin.

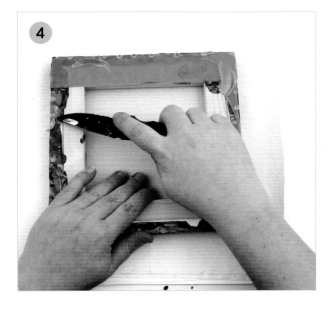

Resin takes about 24 hours to harden. If any areas of the canvas are uncovered, you can add a second coat of resin after 24 hours. Remove the tape after 72 hours.

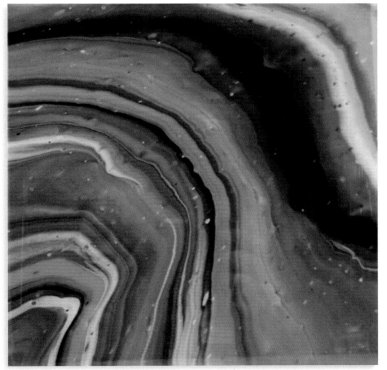

Saving Leftover Paint

If you are a recycler, paint pouring makes for the ideal technique, as you can reuse old household items, like colanders (see pages 74-79), in addition to saving leftover paint for later use. Saving paint reduces waste, and it helps me get creative with my other art projects too. I save leftover paint as a skin (see below) on freezer paper, a silicone baking mat, or watercolor paper. Then I can use the leftover paint to make jewelry (pages 106-109), bookmarks (116-119), greeting cards, and magnets (124-127).

SAVING PAINT IN CONTAINERS

You can save paint in almost any container, including a mason jar, condiment container, or water or soda bottle. I usually don't store my paint for very long (a couple of days at most), so plastic wrap with a rubber band around it works well as a short-term solution for covering leftover paint.

If you use an airtight container, you can save your paint for longer periods of time.

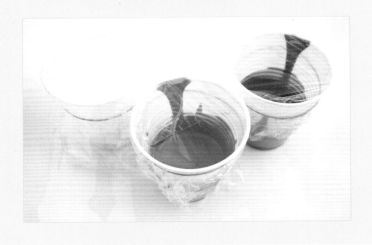

MAKING ACRYLIC SKINS

If your paint colors have been mixed, the process of saving the paint will require a few more steps.

By now, you've already prepared your paint, and you can choose any method you like to pour it onto another surface for saving. I used a dirty pour here (see pages 38-43).

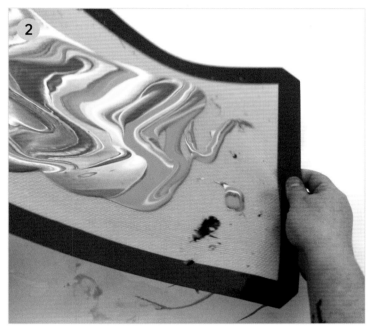

Pour your paint onto your surface, such as this silicone baking mat. Tilt to spread the paint and lay flat to dry.

IF YOUR PAINT MIXTURE CONTAINS SILICONE, GENTLY TORCH IT, TAKING CARE NOT TO BURN THE PAINT OR THE SURFACE BY HOLDING THE TORCH IN ONE PLACE FOR TOO LONG.

Once dry, you can peel off the acrylic piece, known as "acrylic skin," if you've used freezer paper or a silicone baking mat. If you used watercolor paper, the paint won't peel off, but the painted pieces of paper can still be used like acrylic skin.

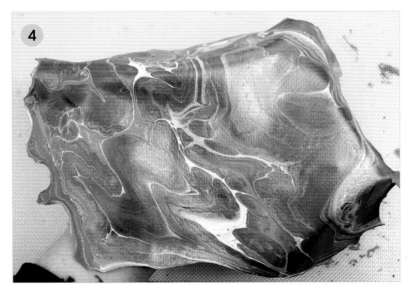

Here is the leftover paint once dry and ready to use.

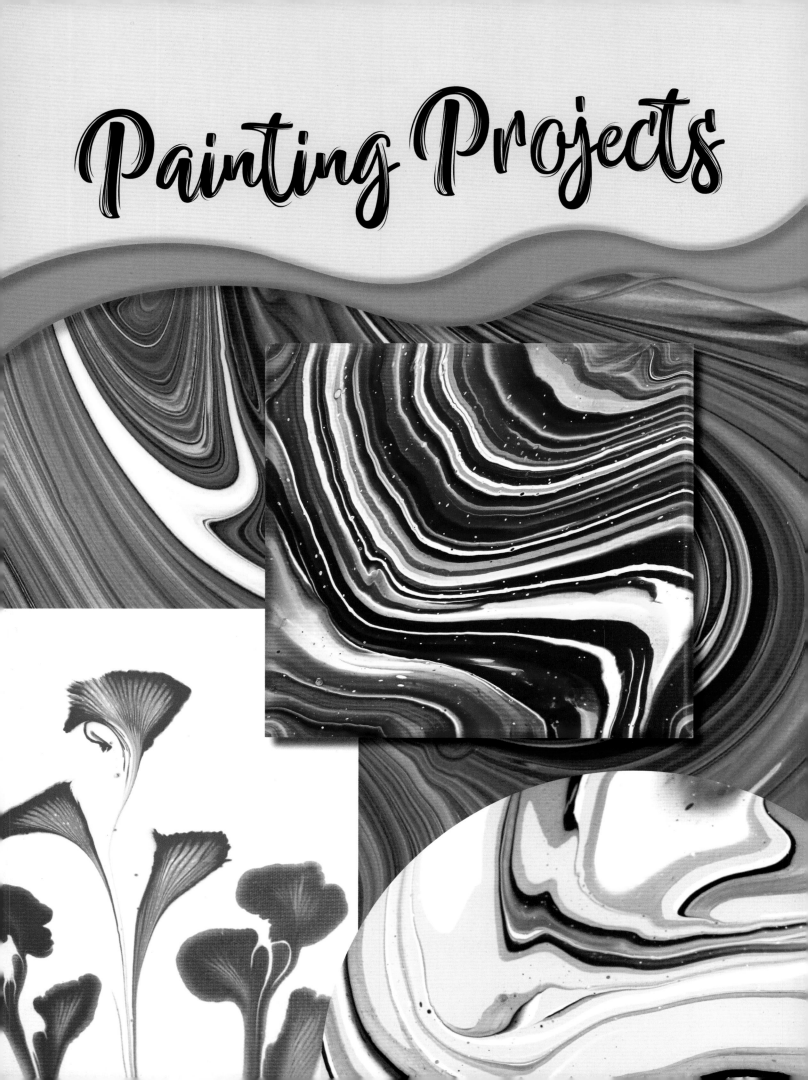

Painting Projects

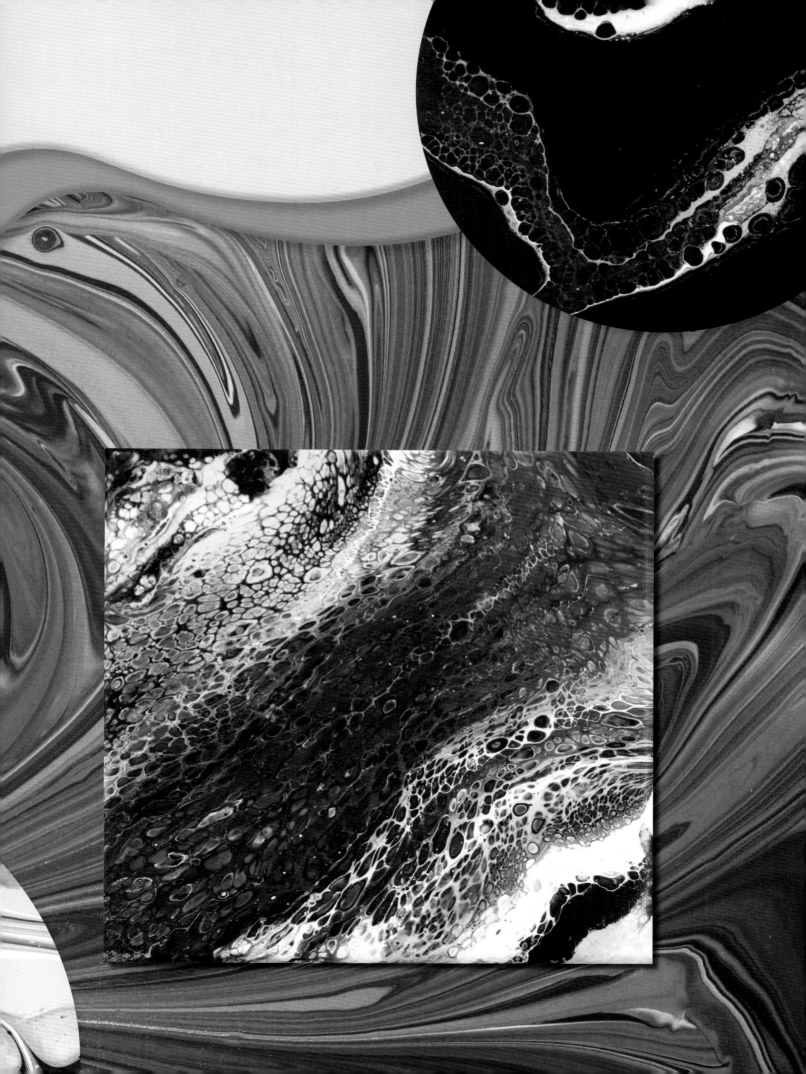

Dirty Pour

The dirty pour is the very first paint pouring technique I tried, and it is one of the easiest to learn. Simply add your paints to individual containers, pour them into a single cup, and then pour the mixture onto your canvas.

TOOLS & MATERIALS:
- Freezer paper
- Canvas
- Cups
- Pouring medium
- Wooden stir sticks
- Water

Optional tools for creating cells:
- Liquid silicone or dimethicone
- Kitchen or butane torch

STEP 1

Lay a sheet of freezer paper over your working surface. You can also use a plastic bag, newspaper, or a tablecloth—anything that keeps your working area clean of paint.

Rest your canvas on top of cups. I used four—one for each corner of the canvas. Elevating your canvas allows the excess paint to run off the sides.

USE A LEVEL TO CHECK THAT YOUR CANVAS IS COMPLETELY HORIZONTAL IF YOU PLAN TO LEAVE IT ON THE CUPS TO DRY.

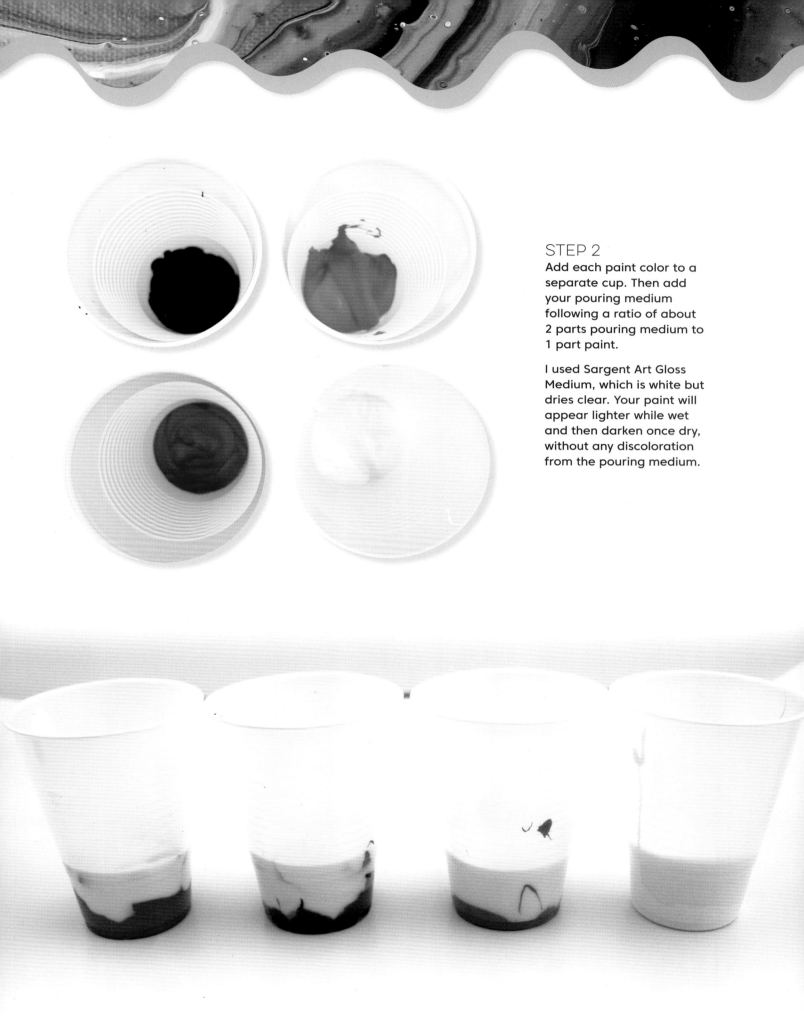

STEP 2

Add each paint color to a separate cup. Then add your pouring medium following a ratio of about 2 parts pouring medium to 1 part paint.

I used Sargent Art Gloss Medium, which is white but dries clear. Your paint will appear lighter while wet and then darken once dry, without any discoloration from the pouring medium.

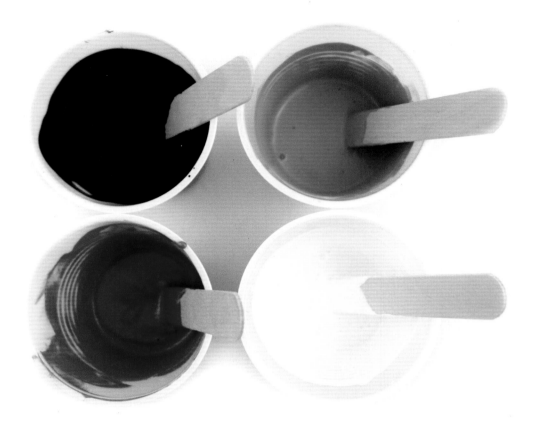

STEP 3

Use stir sticks to mix the paint and medium, ensuring that there are no lumps. Lumps in the paint will be visible when you pour it onto the canvas.

Then slowly add water until the paint mixture reaches a consistency that's ideal for pouring. I like to add water 1 tablespoon at a time and mix until well-blended, aiming for a thickness similar to honey or heavy cream. If your paint is too thick, it won't move well on the canvas, and if it's too thin, the colors will blend and turn muddy.

If you wish to create cells in your piece (see pages 22-27), mix in a drop of two of silicone or dimethicone now.

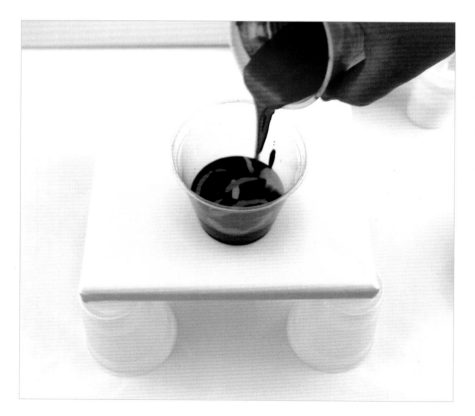

STEP 4

With your paint mixtures ready and your canvas set up, you are ready to begin pouring!

Grab an empty cup, and start adding paint to it for your dirty pour. You can pour the paints in any order and volume that you like.

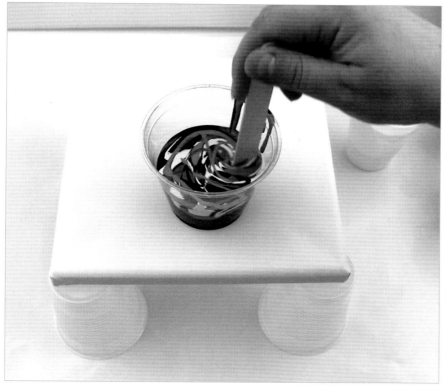

ONCE YOU'VE POURED YOUR PAINT COLORS INTO THE CUP, YOU CAN USE A STIR STICK TO GENTLY MIX THEM. DO NOT OVERMIX OR THE PAINT WILL TURN MUDDY. MIXING THE PAINT CAN CREATE A MORE BLENDED COLOR PALETTE.

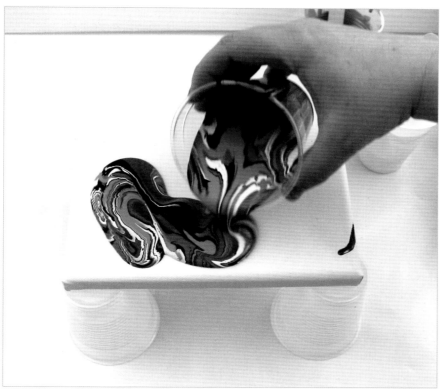

STEP 5
Now it's time to pour your paint! You can pour it in any design you like: diagonally across the canvas, in a circular motion, or in one large puddle in the middle.

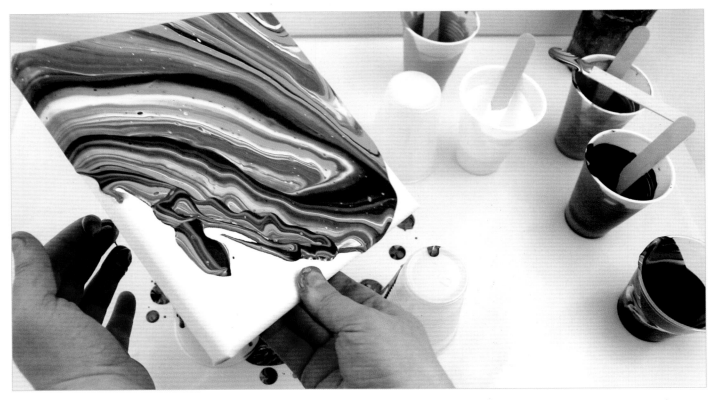

STEP 6
Pick up and tilt the canvas in any direction you wish. Keep areas of your artwork that you like, and tilt off what you don't like.

If you don't like what you've poured and tilted, don't worry! Add paint to your cup and pour a little more onto the canvas. Because the paint stays wet for a couple of days, you can take your time and manipulate the paint any way you want. There is no need to rush the process.

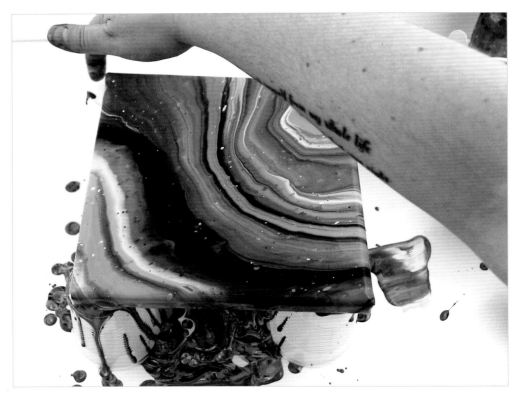

STEP 7
When you are satisfied with your design, rest your canvas on a flat surface or on the cups to let it dry. Check the sides and the edges of the canvas to make sure they're completely covered with paint. If you can still see parts of the canvas, use leftover paint to touch it up by hand.

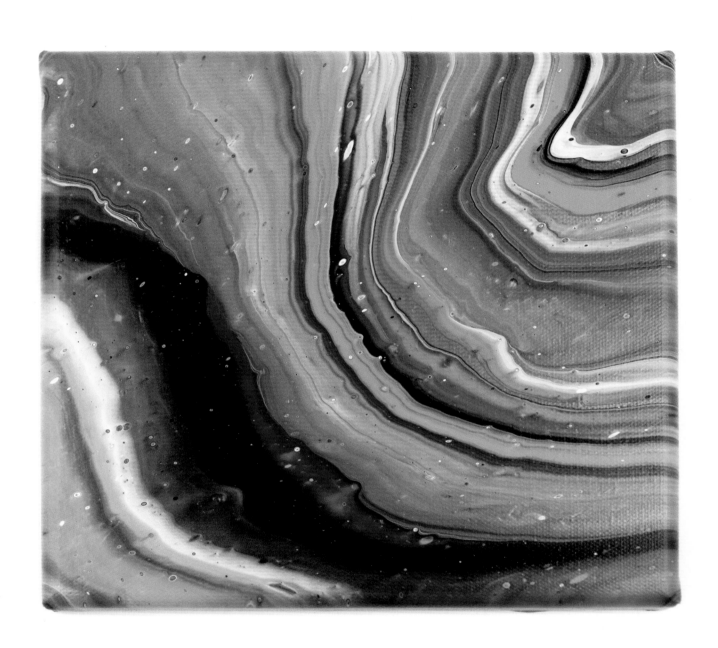

IT MAY TAKE YOUR ARTWORK 1 TO 3 DAYS TO DRY. TEMPERATURE AND HUMIDITY LEVELS WILL AFFECT THE DRYING TIME.

Flip Cup

The flip cup technique is another simple, popular paint pouring technique. With this method, you mix your colors individually, add them all to one cup, flip the cup onto the canvas, and then pull the cup away to reveal the paint. You can do this method with or without adding silicone, depending on whether you want to form a lot of cells in your artwork.

TOOLS & MATERIALS:
- Freezer paper
- Cups
- Canvas
- Paint pouring medium
 (I used Floetrol, which helps create cells)
- Water
- Stir sticks

Optional tools for creating cells:
- Torch
- Liquid silicone or dimethicone (I used a hair serum that works well for creating cells)

STEP 1
Cover your flat working surface with a sheet of freezer paper. For this technique, I used an 8" x 10" canvas, which I propped up with four cups so that the excess paint would run off the sides.

DEPENDING ON THE SIZE OF YOUR CANVAS, YOU MAY NEED TO USE MORE CUPS TO KEEP IT LEVEL. ALSO, MAKE SURE THAT YOUR CUPS REST ON THE WOOD FRAME, NOT ON THE CANVAS. IF THE CANVAS MATERIAL RESTS ON THE CUPS, THEIR INDENTATIONS MAY BE VISIBLE ONCE THE ARTWORK DRIES.

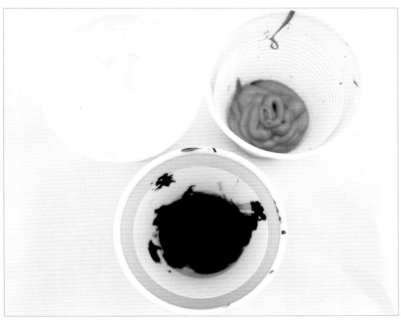

STEP 2
Select your paint colors and add each color to a separate cup. For this painting, I used purple, white, and pewter.

Add your pouring medium, following a ratio of about 2 parts medium to 1 part paint.

IF YOU ADD TOO MUCH WATER AND THE PAINT MIXTURE BECOMES TOO THIN, YOU CAN ADD A SMALL AMOUNT OF PAINT TO THICKEN IT BACK UP. PRACTICING WITH DIFFERENT CONSISTENCIES WILL HELP YOU DETERMINE HOW THICK OR THIN YOU LIKE YOUR PAINT.

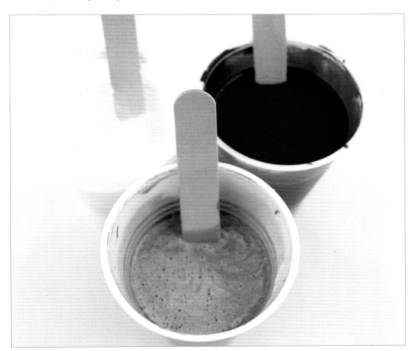

STEP 3
Thoroughly mix the paint and the medium. Then slowly add water until your mixture reaches the consistency that you prefer for pouring. I like to add about 1 tablespoon at a time, mix it in, and check to see if I need more water.

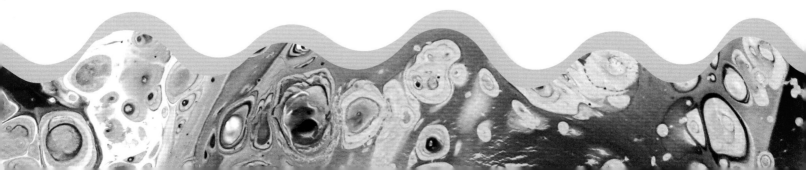

STEP 4
Add a small amount of silicone or dimethicone to your paint mixture. I added one or two drops of silicone to the cup and then gently stirred.

ONCE YOU'VE POURED YOUR PAINT, IF YOU SEE CRATERS OR AREAS OF THE PAINT PULLING AWAY FROM THE CANVAS, YOU MAY HAVE ADDED TOO MUCH SILICONE, OR YOUR PAINT MIXTURE COULD BE TOO THIN. REMIX AND TRY AGAIN!

STEP 5
When you've mixed the paint to your desired consistency, grab an empty cup and add the paint colors in any order and amount.

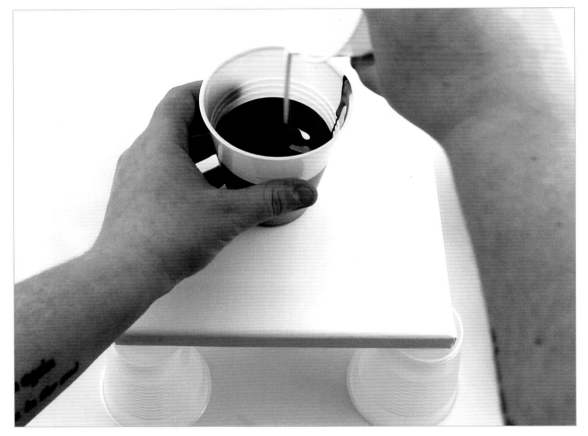

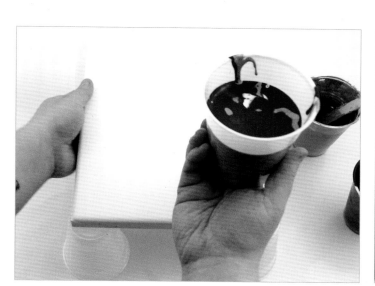
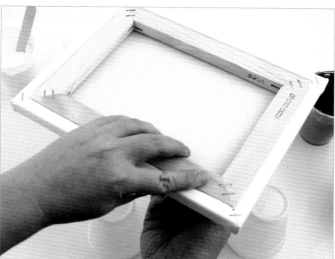

STEP 6

Now for the fun part! Place the canvas on top of your cup of paint. Hold the canvas in one hand and the paint cup in the other, and flip both over.

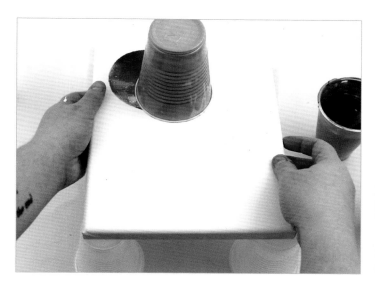
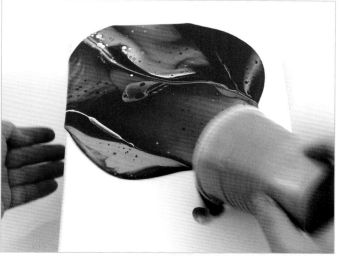

STEP 7

Place the canvas back onto the resting cups that you laid out during step 1. You can briefly leave the cup on the canvas, or immediately remove it. Pull the cup away from the puddle of paint on the canvas; do not lift it.

LIFTING THE CUP FROM THE PUDDLE OF PAINT MAY RUIN YOUR DESIGN. BY PULLING AWAY THE CUP, YOU PREVENT THE PAINT FROM DRIPPING.

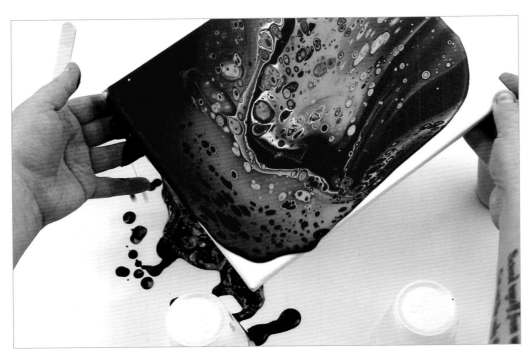

STEP 8

Before tilting your canvas, you may use a torch to create cells. By torching first and tilting second, you can create cells and then tilt them to form larger cells across your canvas. If you prefer smaller cells, tilt the canvas first, and then apply the torch.

TO AVOID BURNING YOUR PIECE, REMEMBER NOT TO KEEP THE TORCH TOO CLOSE TO THE CANVAS OR IN ONE PLACE FOR LONG.

STEP 9

Once you've created a design that you like, touch up the sides and edges of the canvas, and then lay it on the four cups or another flat surface to dry.

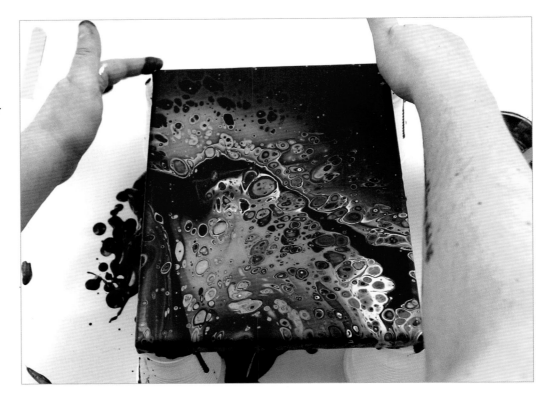

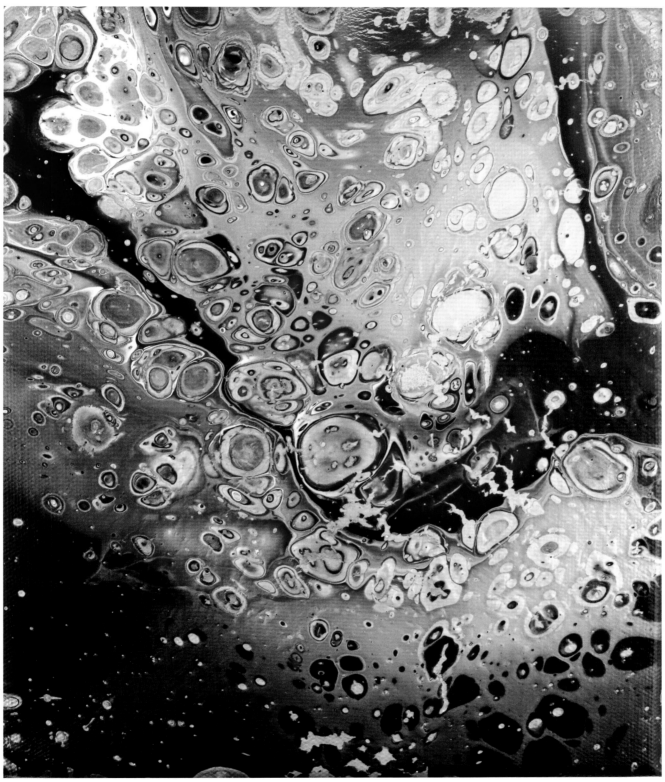

Here you can see the cells in my final piece. The pewter paint adds a fun pop of metallic color!

Puddle Pour

When I was learning to pour paint, I first tried some of the most basic techniques, and then branched out to see what other styles and designs I could create. One of my favorite slightly more advanced techniques is the puddle pour, in which you pour paint into a puddle on the canvas, and then tilt the canvas to create a beautiful design.

TOOLS & MATERIALS:
- Freezer paper
- Cups
- Wooden surface
- Pouring medium
- Water
- Stir sticks

Optional tools for creating cells:
- Silicone or dimethicone
- Torch

STEP 1

Lay a sheet of freezer paper flat over your working surface. Place four cups on top of the freezer paper, and then lay your wooden surface on the cups.

STEP 2

Pour your paint colors into individual cups. I used white, brown, pewter, and blue. I created a light blue color by mixing white with dark blue.

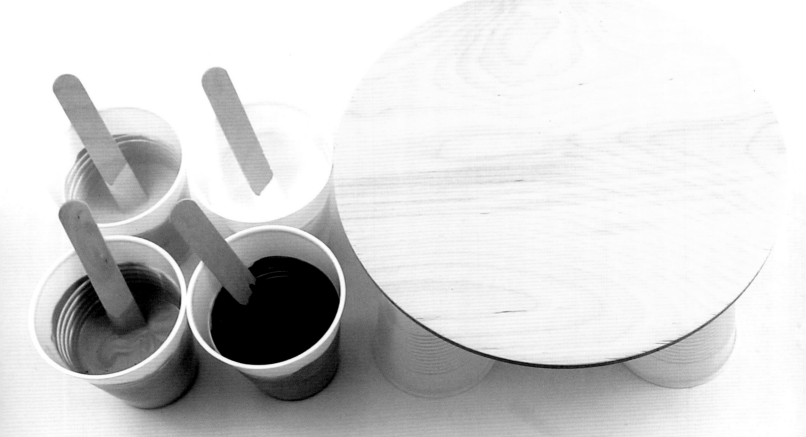

WHEN MIXING COLORS, ADD A SMALL AMOUNT OF PAINT AT A TIME AND INCORPORATE IT COMPLETELY. TO CREATE A DARKER SHADE, ADD MORE OF THE PAINT COLOR. FOR A LIGHTER SHADE, ADD WHITE.

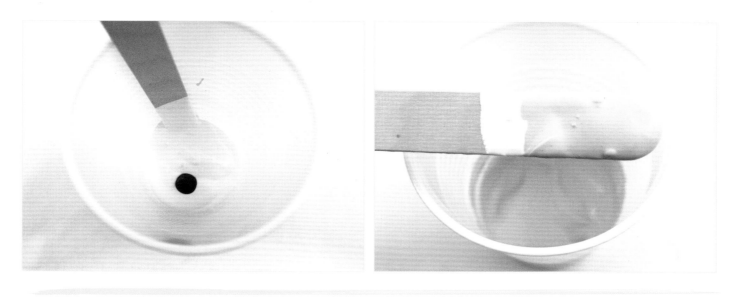

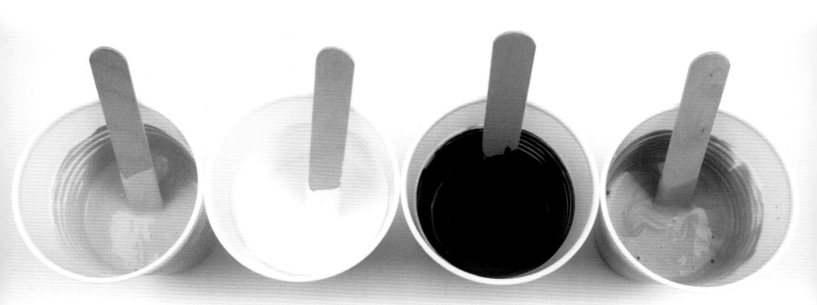

STEP 3
Add pouring medium to your cups of paint. I used 2 parts medium to 1 part paint. Mix thoroughly and slowly add water until the paint reaches your desired consistency.

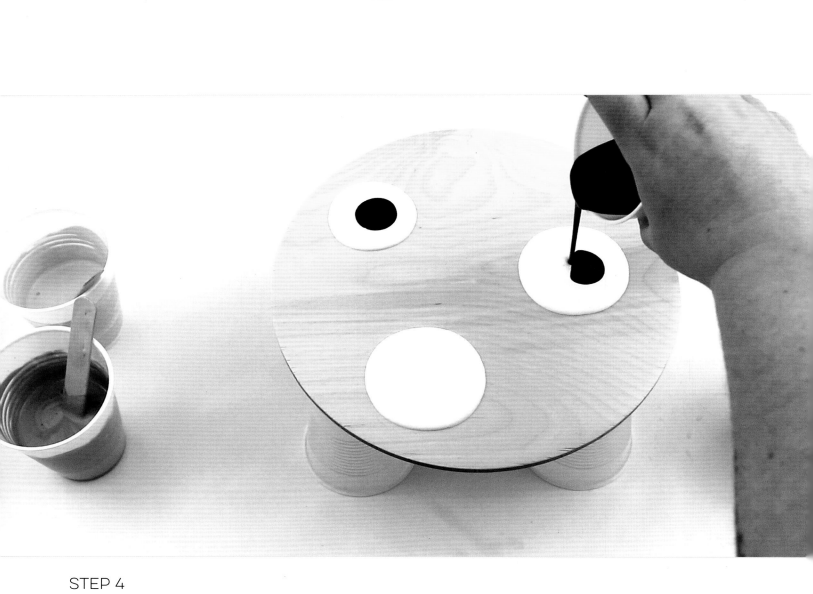

STEP 4

The puddle pour technique is different from some of the others in this book because it doesn't require mixing the paint colors before pouring them. Instead, you'll leave each color in its own cup and mix directly on your painting surface.

Pour your first color onto the wooden surface. You can create a single puddle of paint or pour your paint into multiple puddles.

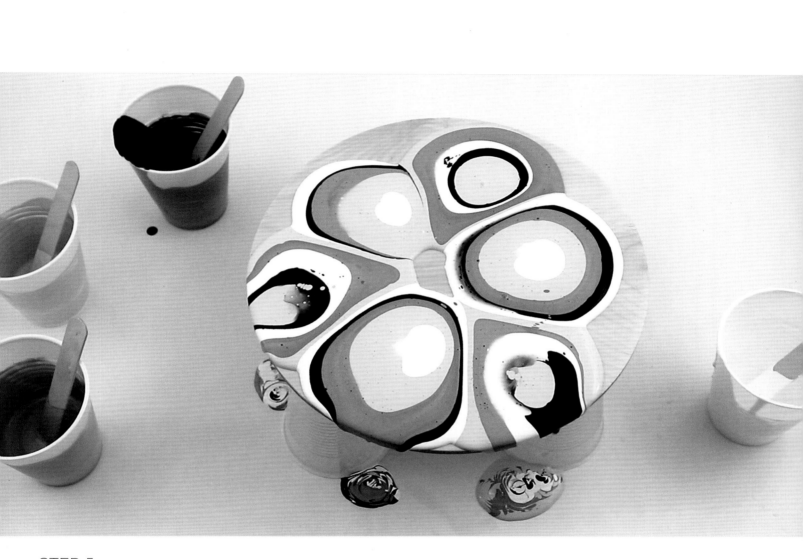

STEP 5

Choose another paint color and pour it onto your first puddle(s) of paint. Repeat with your other paint colors, adding them in any order and amount that you like.

Now is also the time to use a torch, if you choose to do so. See page 10 for torching instructions.

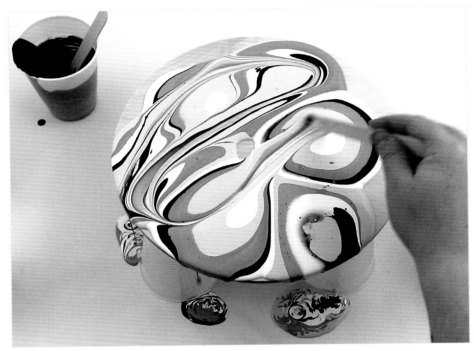

STEP 6

Once you've poured all your paint colors, begin tilting your wooden surface.

BEFORE TILTING THE SURFACE, YOU CAN USE YOUR FINGER OR A STIR STICK TO GENTLY MOVE THROUGH THE PAINT.
THIS WILL BREAK UP THE COLORS AND CREATE INTERESTING DESIGNS.

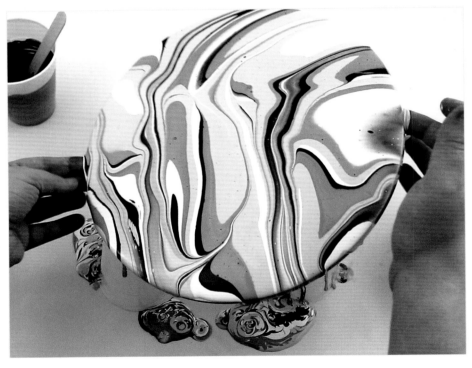

STEP 7

Once you've tilted your piece and created a design that you like, rest your surface flat on a table. I've found that if my wooden surface isn't supported, it can warp during drying. Laying it flat on a table, instead of on cups, provides equal support across the entire surface.

YOU CAN USE A LEVEL TO MAKE SURE YOUR DRYING SURFACE LAYS EVENLY. IF IT'S UNEVEN, YOUR PAINT MIGHT MOVE DURING DRYING.

TRY THIS TECHNIQUE BOTH WITH AND WITHOUT MOVING YOUR FINGER OR A STIR STICK THROUGH THE PAINT PUDDLES TO SEE THE DESIGNS YOU CAN CREATE. YOU CAN ALSO ADD SILICONE TO SOME OF YOUR PAINT MIXTURES TO CREATE CELLS WHEN LAYERING PUDDLES OF PAINT.

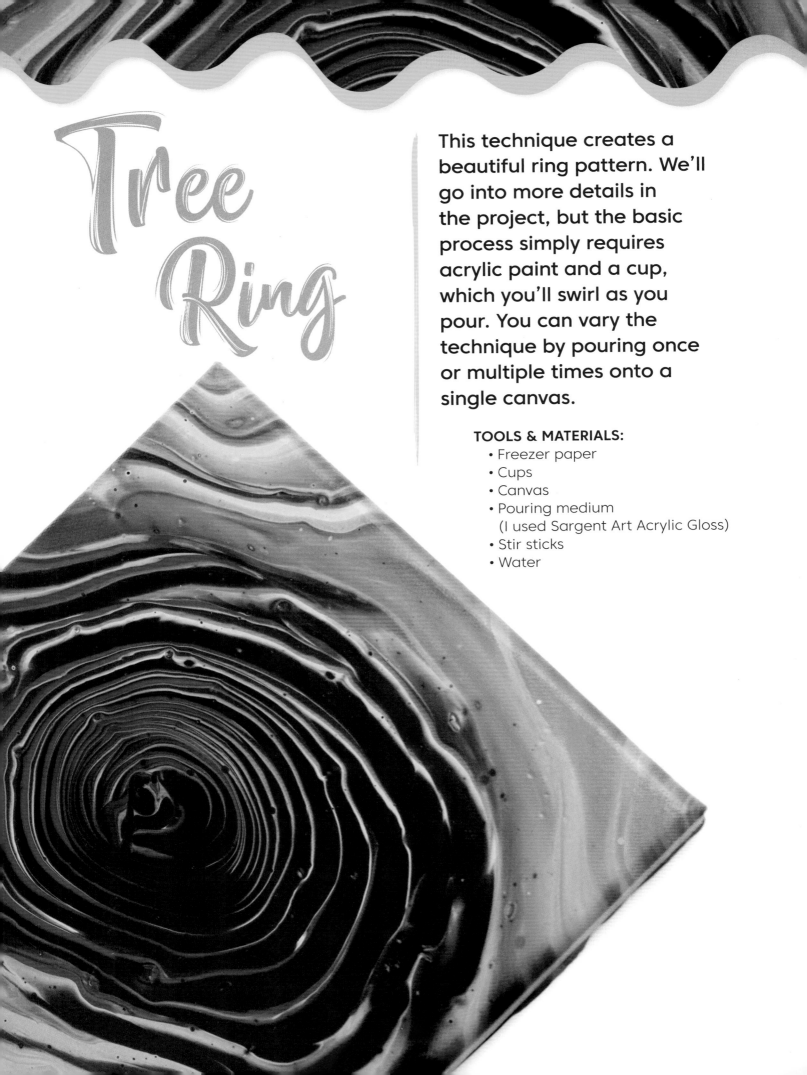

Tree Ring

This technique creates a beautiful ring pattern. We'll go into more details in the project, but the basic process simply requires acrylic paint and a cup, which you'll swirl as you pour. You can vary the technique by pouring once or multiple times onto a single canvas.

TOOLS & MATERIALS:
- Freezer paper
- Cups
- Canvas
- Pouring medium
 (I used Sargent Art Acrylic Gloss)
- Stir sticks
- Water

TO CREATE EVEN RINGS IN YOUR FINAL PIECE, DO NOT ADD SILICONE TO YOUR PAINT MIXTURE. SILICONE CREATES CELLS AND BREAKS UP THE RING PATTERN.

STEP 1

Lay a sheet of freezer paper over your working surface. Place four cups facedown on the paper, and rest the canvas on top.

Add your paint colors to cups, and then mix in the pouring medium of your choice. I used a rainbow of colors: red, orange, yellow, green, blue, and purple, plus 2 parts pouring medium to 1 part paint.

Slowly mix in water until the paint reaches the consistency you want for pouring.

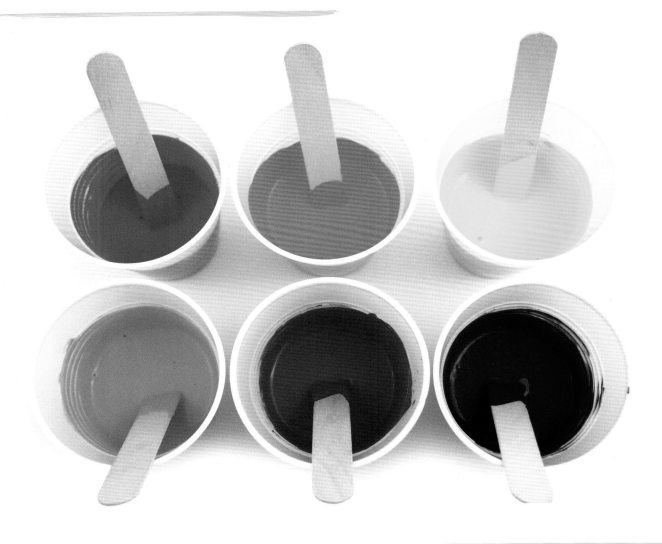

FOR THIS TECHNIQUE, I LIKE TO KEEP MY PAINT MIXTURES THICKER SO THEY WON'T BLEND TOO MUCH WHEN ADDED TO THE POURING CUP.

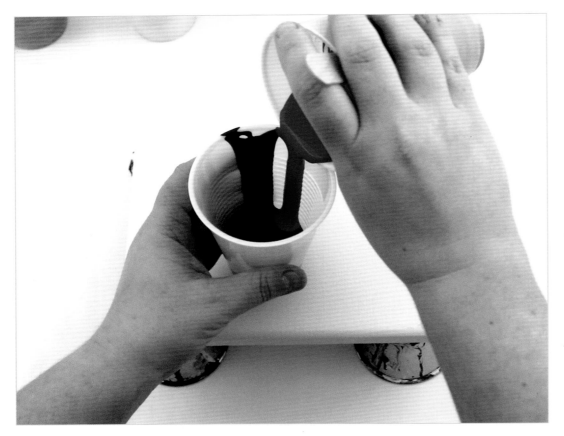

STEP 2

Gently pour each paint mixture into a single pouring cup. I like to layer my paint colors so that they stay somewhat separated when poured.

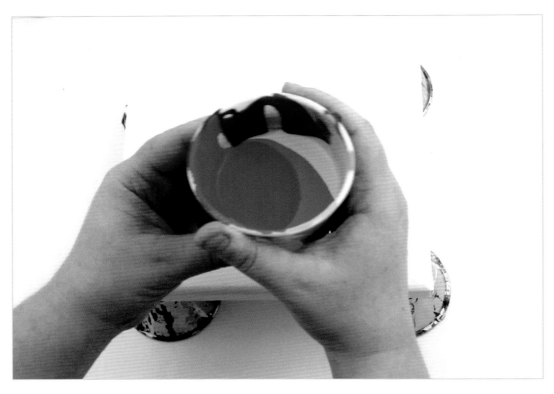

To keep the paint separated, pour it against the side of cup, ensuring that the paint rests on top of the colors already in the cup.

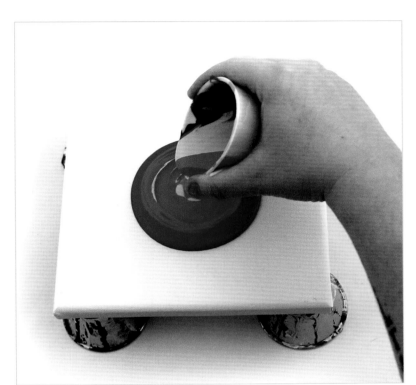

STEP 3

Start pouring your paint. To create a tree ring effect, swirl the cup in a circular pattern as you pour.

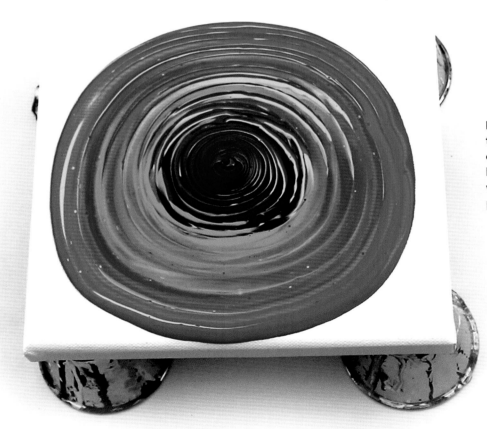

Here, you can see the rainbow of colors I produced because of the way I poured the paint into the cup.

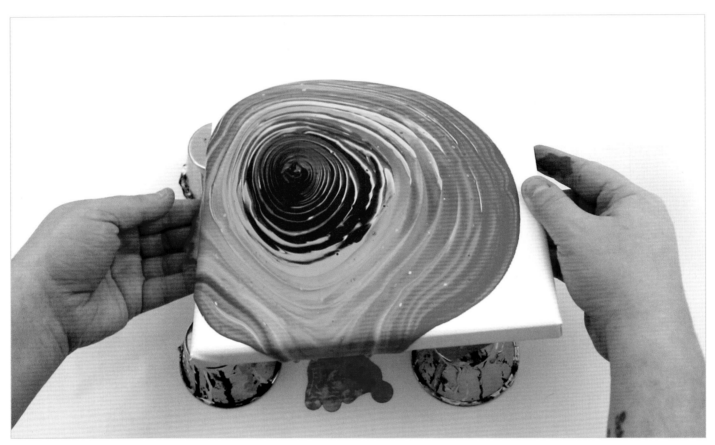

STEP 4
Gently tilt the canvas to spread the paint, and let it dry on a flat surface before displaying.

IF YOU'RE HAPPY WITH YOUR PATTERN BUT STILL HAVE AREAS OF BARE CANVAS, USE A PAINTBRUSH, A PALETTE KNIFE, OR YOUR FINGERS, PLUS LEFTOVER PAINT OR ANOTHER COLOR— LIKE BLACK OR WHITE—TO COVER THE BLANK SPACES.

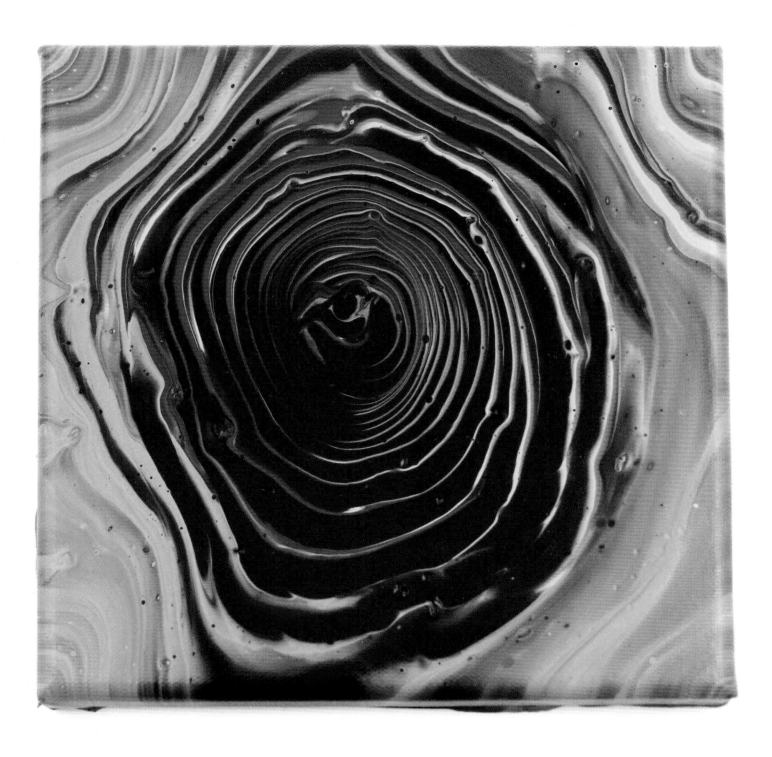

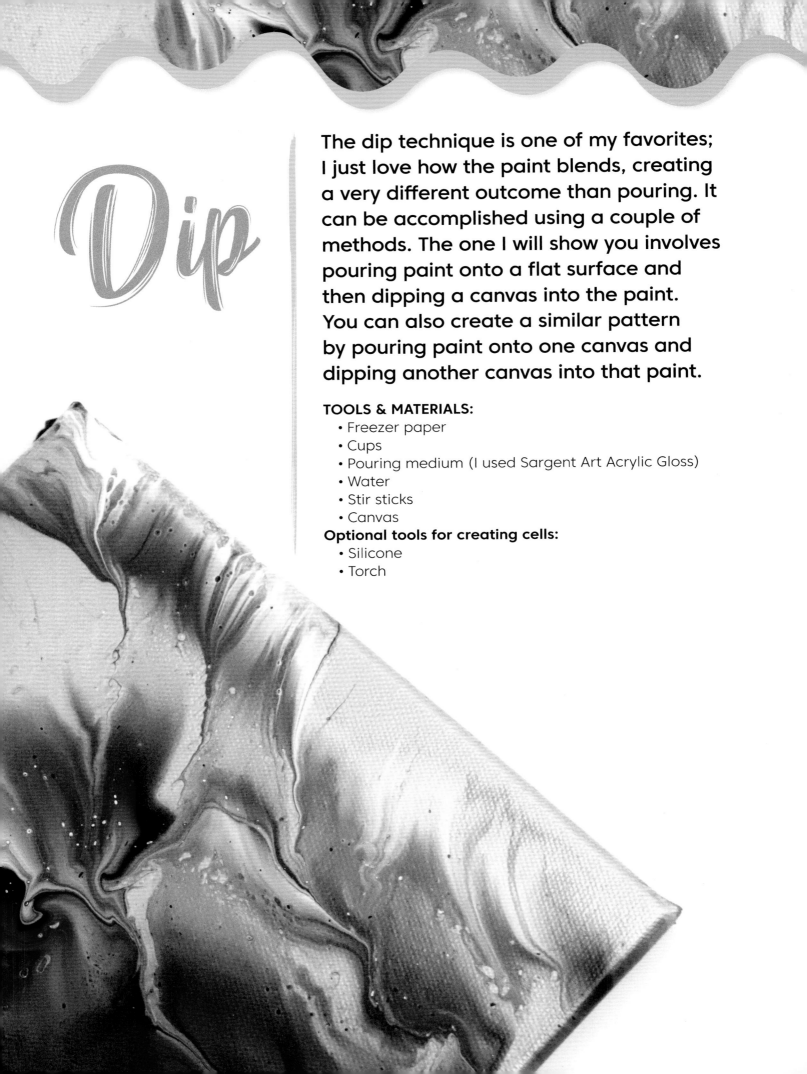

Dip

The dip technique is one of my favorites; I just love how the paint blends, creating a very different outcome than pouring. It can be accomplished using a couple of methods. The one I will show you involves pouring paint onto a flat surface and then dipping a canvas into the paint. You can also create a similar pattern by pouring paint onto one canvas and dipping another canvas into that paint.

TOOLS & MATERIALS:
- Freezer paper
- Cups
- Pouring medium (I used Sargent Art Acrylic Gloss)
- Water
- Stir sticks
- Canvas

Optional tools for creating cells:
- Silicone
- Torch

STEP 1

Place freezer paper over your working surface. For this technique, you do not need to rest your canvas on top of cups.

I used three paint colors: purple, light rose gold, and white. Create your own pouring mixture using a ratio of about 2 parts pouring medium to 1 part paint. Slowly add water and mix until you're happy with the consistency of your paint.

Optional: If you want to use silicone, add one or two drops now, and gently mix it into the colors.

STEP 2

Because this technique involves pouring paint on the freezer paper and then dipping the canvas in the paint, it's helpful to mark the area of the canvas onto the freezer paper. This will ensure that you pour the right amount of paint onto the freezer paper.

STEP 3

Now, pour your paint into a cup. Then pour the paint onto the freezer paper as a dirty pour (see pages 38-43). Another option is to pour the paint colors separately onto the freezer paper in any pattern you like.

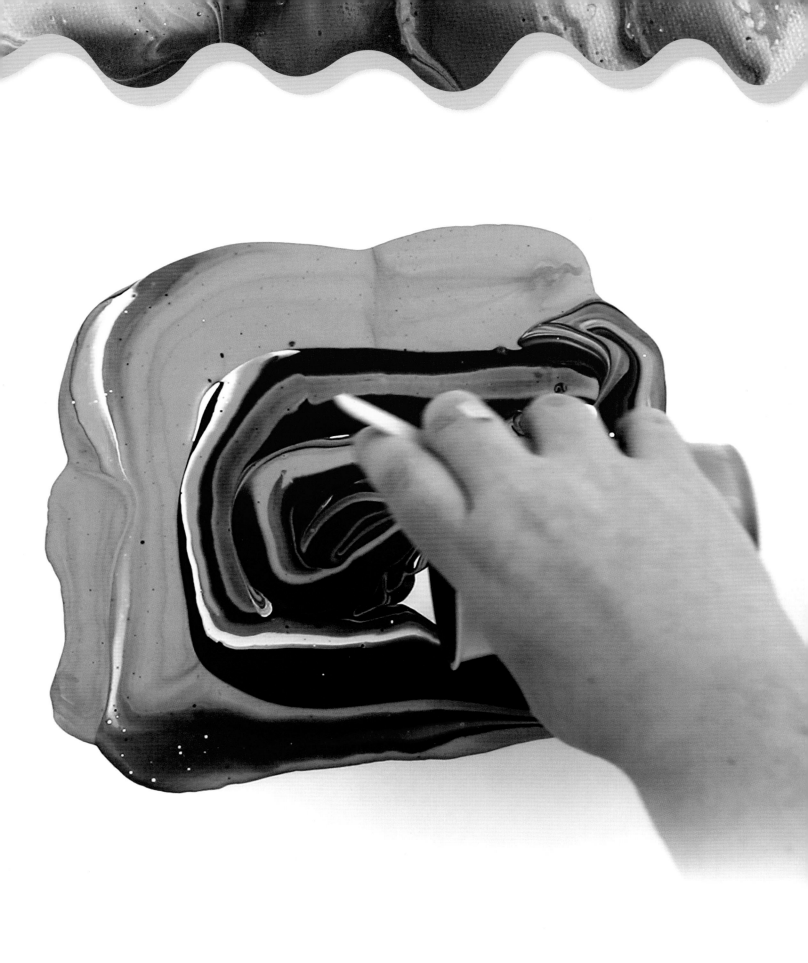

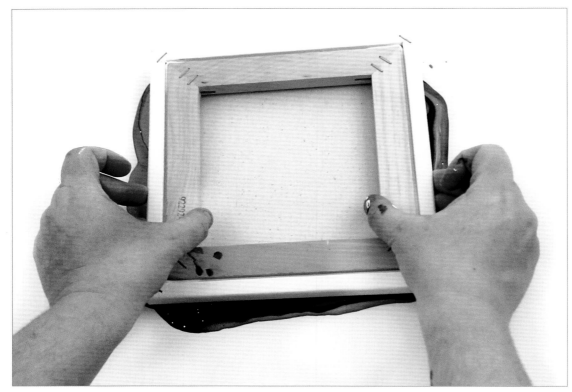

STEP 4

Dip the canvas into the paint poured onto the freezer paper. Air may be trapped under the canvas; gently press down on the center to ensure that the entire canvas touches the paint.

Then grab an edge or a corner of the canvas, and gently pull it away from the freezer paper.

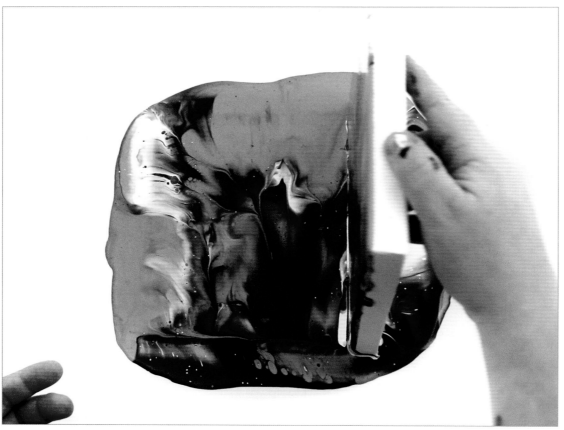

STEP 5

Cover the sides of the canvas by dipping them into the paint. Then touch up any blank areas of the canvas, and set it on a flat surface to dry.

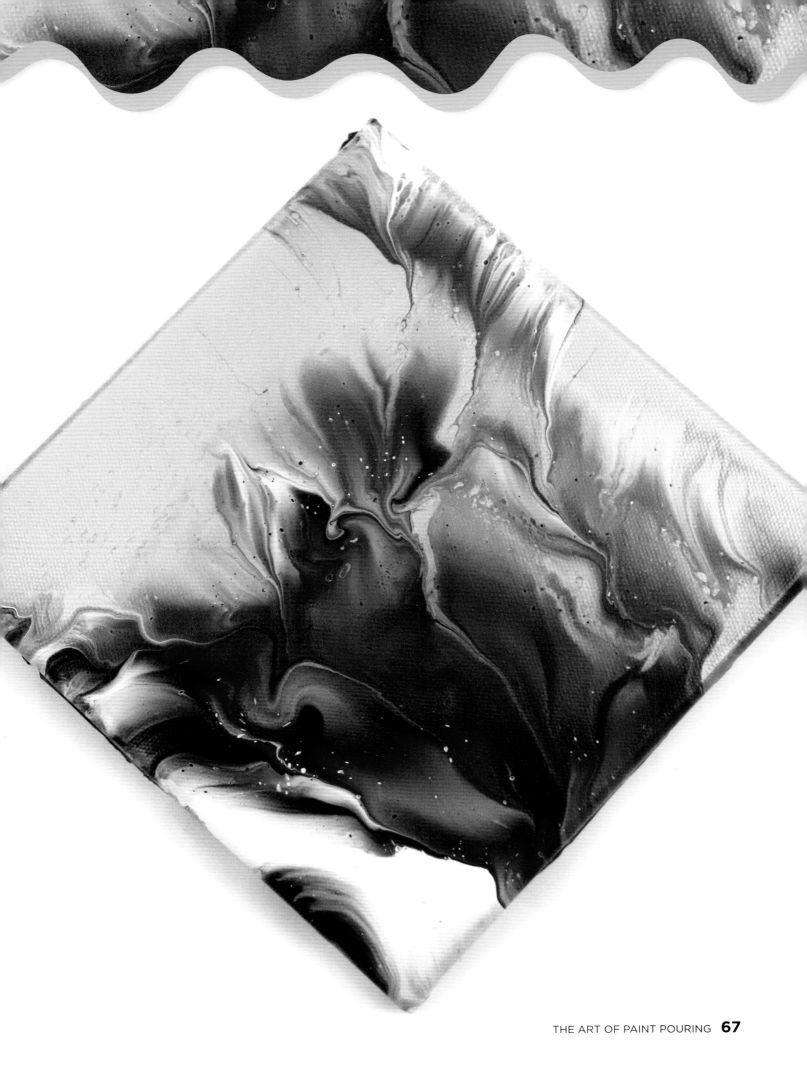

Swipe

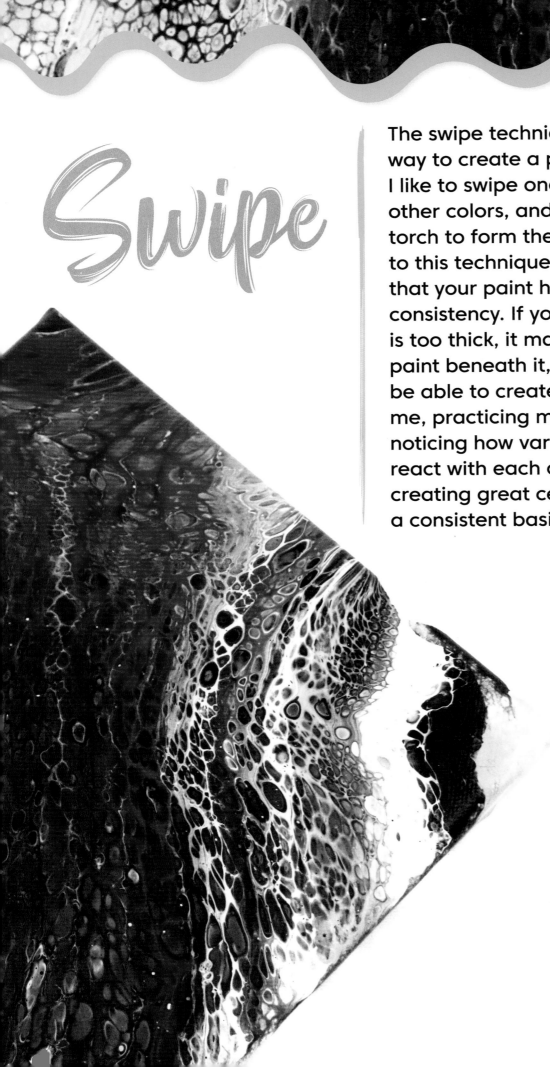

The swipe technique is a popular way to create a piece full of cells. I like to swipe one color over my other colors, and then I apply a torch to form the cells. The trick to this technique is ensuring that your paint has the correct consistency. If your swipe color is too thick, it may sink into the paint beneath it, or you may not be able to create cells at all. For me, practicing mixing paints and noticing how various consistencies react with each other is the key to creating great cell formations on a consistent basis.

TOOLS & MATERIALS:
- Cups
- Pouring medium
- Water
- Silicone
- Stir sticks
- Freezer paper
- Canvas
- Swiping tool, such as a piece of paper, stir stick, palette knife, or paper towel
- Torch

STEP 1

I chose to use beach-inspired colors for this piece. Any color combination will work, however. Choose one color as your swipe color.

Combine 2 parts pouring medium with 1 part paint. Then slowly add water until the mixture reaches the consistency that you like for paint pouring. Add 1 to 2 drops of liquid silicone, and gently incorporate.

KEEP YOUR SWIPE COLOR A LITTLE THINNER THAN THE OTHER PAINT MIXTURES. THIS WAY, THE SWIPE COLOR WILL STAY ON TOP. IF IT'S TOO THICK AND HEAVY, IT MAY SINK INTO THE OTHER PAINT COLORS.

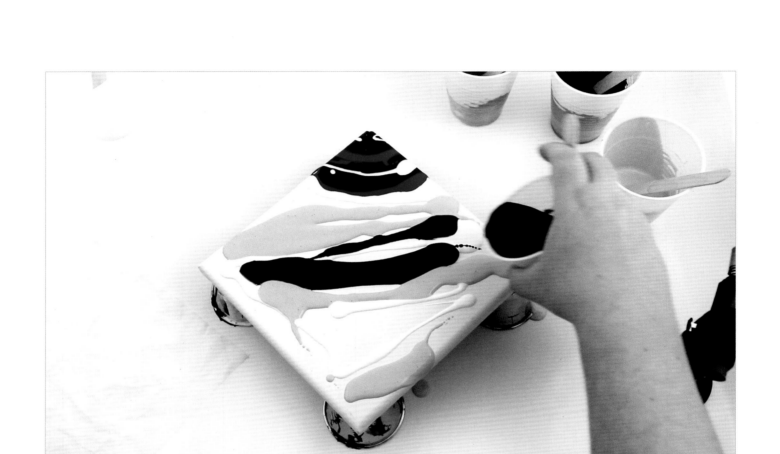

STEP 2
Lay a sheet of freezer paper down on your working surface, and rest your canvas on top of four upside-down cups. Pour your paint mixtures one by one onto the canvas.

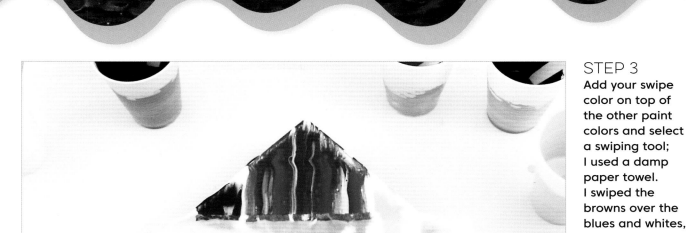

STEP 3

Add your swipe color on top of the other paint colors and select a swiping tool; I used a damp paper towel. I swiped the browns over the blues and whites, but you should feel free to move in any direction that you like.

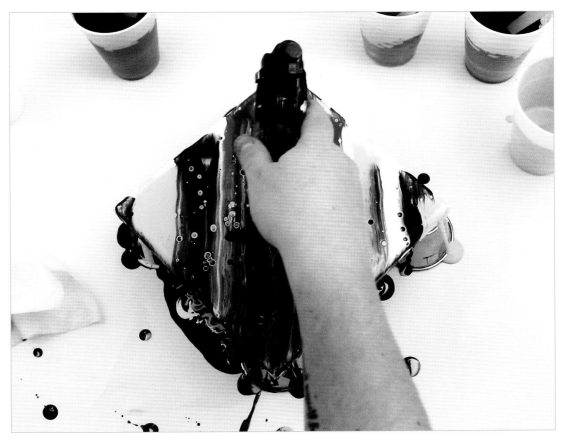

STEP 4

Gently apply your torch over the artwork to heat the paint and create cells. Don't hold the torch in one place for long; it will burn the paint.

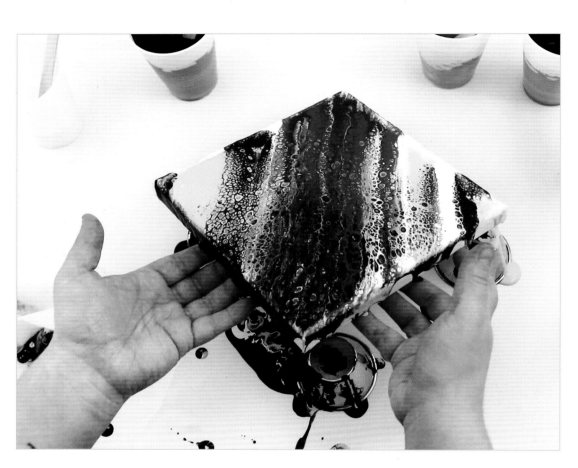

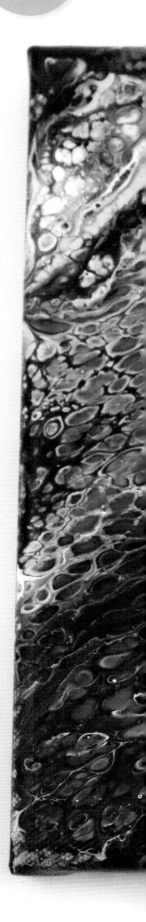

STEP 5

Once you've swiped and created your cells, you can leave the painting as is if you'd like. In my piece, the cells were quite small, so I decided to tilt my canvas and enlarge the cells. This also helped move the paint to cover any blank spaces on my canvas, near the edges.

Then lay your painting on a flat surface to dry.

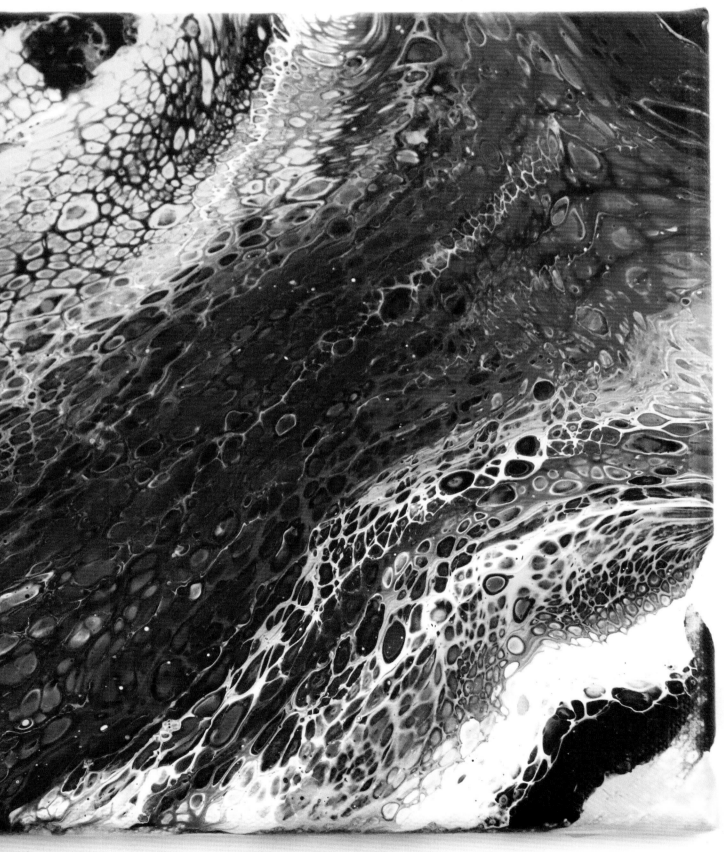

Colander Pour

A colander is a fun tool for producing poured artwork. Colanders come in many shapes, sizes, and designs, and all of these factors will affect your design. Test out a few types of colanders to see what kinds of patterns you can create!

TOOLS & MATERIALS:
- Freezer paper
- Canvas
- Cups
- Colander
- Pouring medium
- Water
- Stir sticks

Optional tools for creating cells:
- Silicone or dimethicone
- Torch

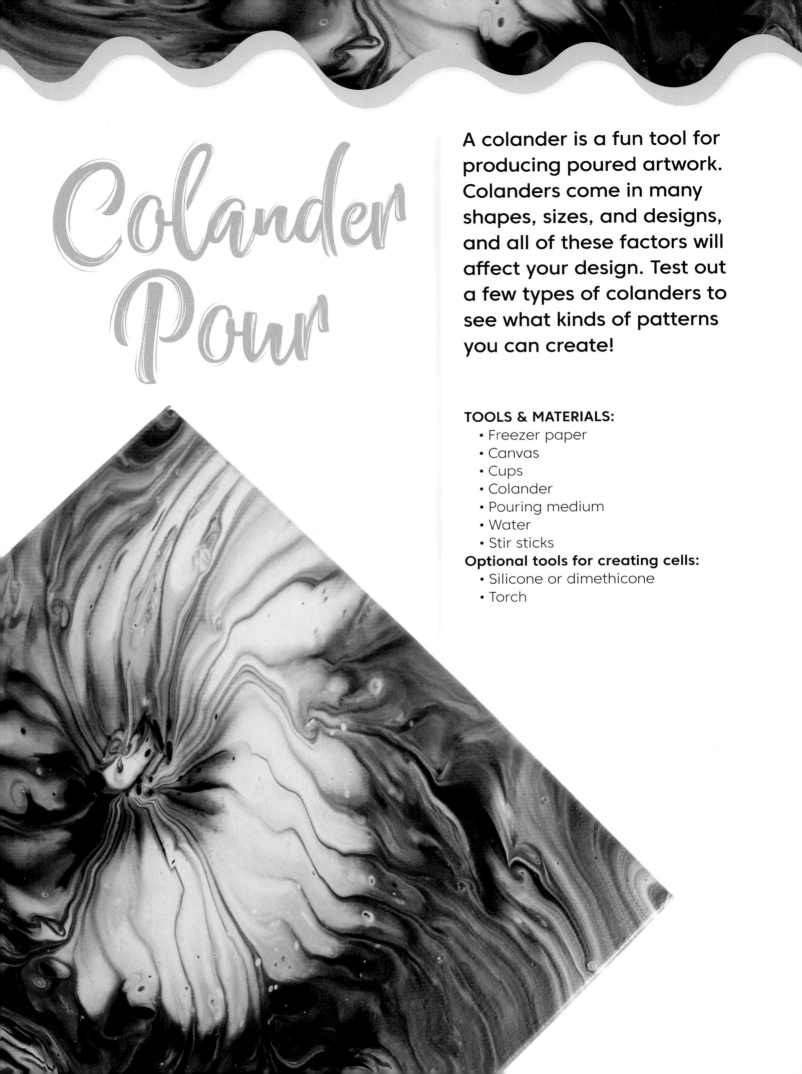

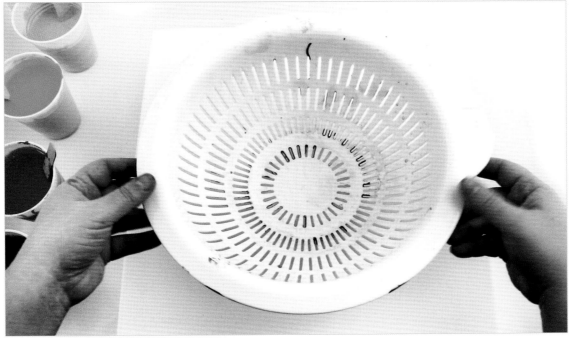

STEP 1

Lay a sheet of freezer paper over your work surface. Rest your canvas on top of upside-down cups, and set the colander in the center of the canvas.

TO CREATE A FUN VARIATION ON THIS DESIGN, PLACE YOUR COLANDER NEAR AN EDGE OR A CORNER OF THE CANVAS, INSTEAD OF IN ITS CENTER.

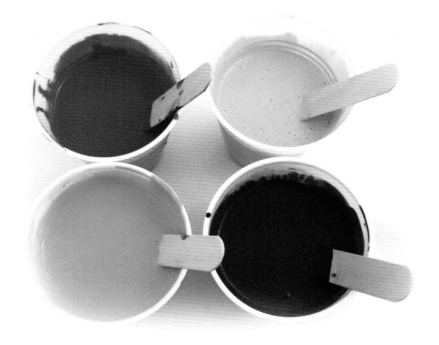

STEP 2

I chose four paint colors for this piece: two shades of blue, green, and purple.

Create your paint mixtures using about 2 parts pouring medium to 1 part paint. Then slowly incorporate water until the mixtures reach the right consistency for paint pouring.

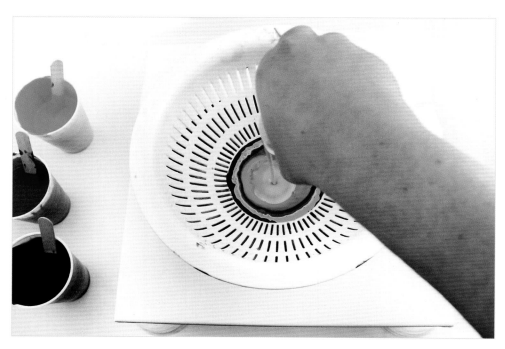

STEP 3

Pour your colors through the middle of the colander. I've chosen to pour them one at a time.

INSTEAD OF POURING YOUR COLORS SEPARATELY, YOU CAN ALSO ADD ALL OF THEM TO A SINGLE CUP AND POUR THEM AS A DIRTY POUR (SEE PAGES 38-43) FOR A MORE BLENDED COLOR DESIGN.

STEP 4

As you pour your paint, it will start to spread over the canvas. Once you've poured a sufficient amount, carefully remove the colander from the canvas.

Note: This can be messy, especially if there's still paint in the colander. Keep a towel or paper towels handy to place under the colander as you remove it from the canvas to avoid paint dripping onto your artwork.

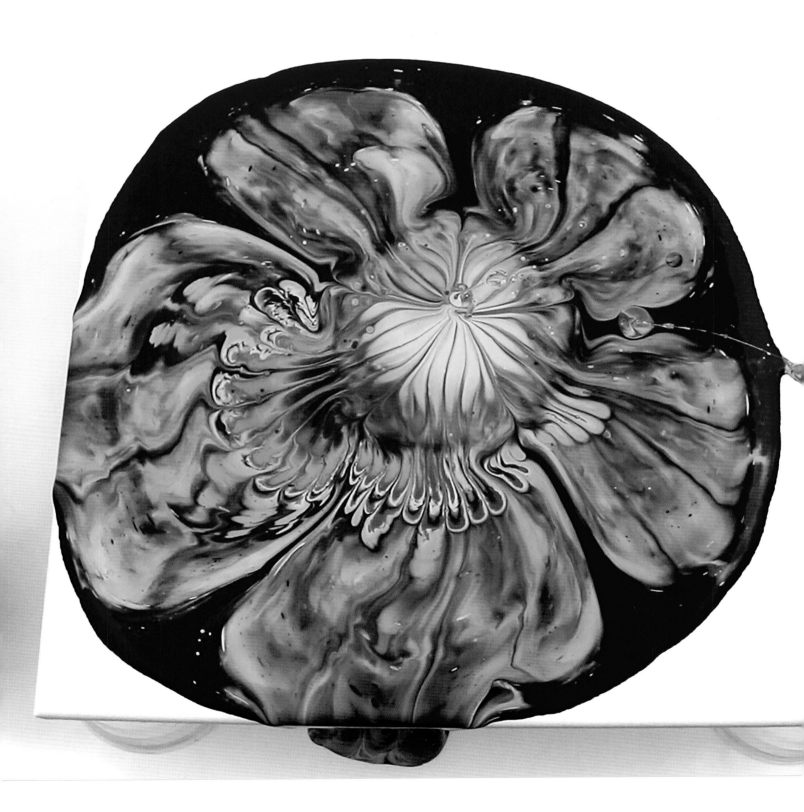

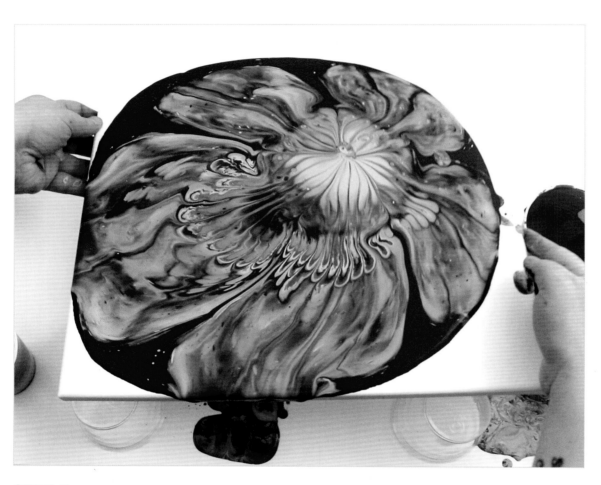

STEP 5

Tilt the canvas. My design wasn't centered on the canvas, so I did a lot of tilting to move the paint and cover the canvas.

Once you're happy with your design, rest the canvas on a flat surface to dry. Use leftover paint to touch up any blank areas on the canvas.

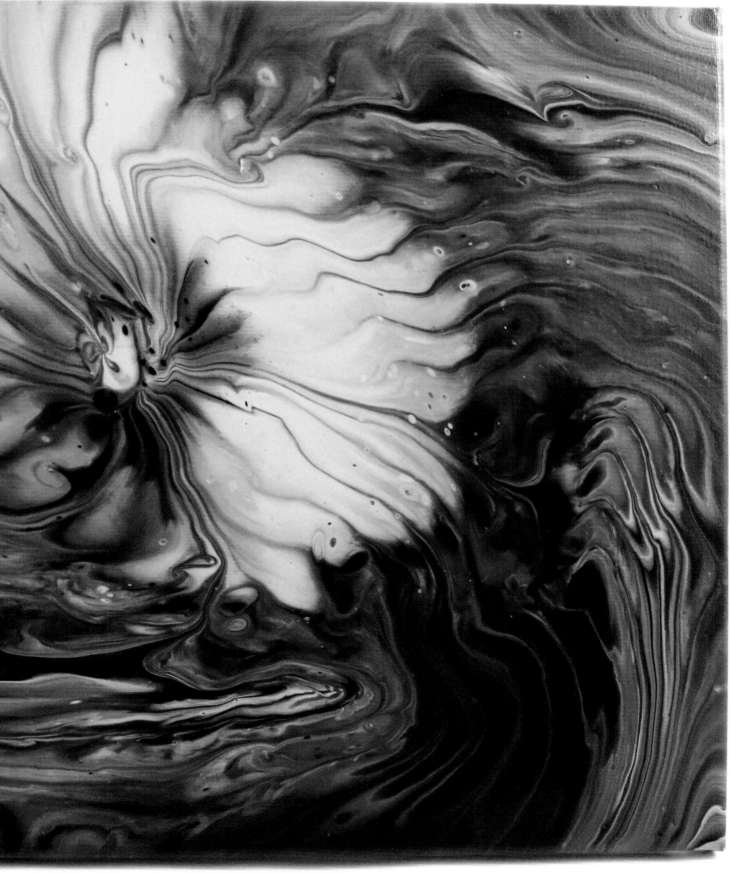

Chain Pull

This technique uses a string or necklace chain to pull one or multiple colors of paint through another color. The materials used will create different patterns, so play around with various supplies and see what you like. You can use this technique to create amazing abstract flowers!

TOOLS & MATERIALS:
- Cups
- Stir sticks
- Pouring medium (I used Floetrol)
- Canvas
- Water
- Freezer paper
- Chain or string (I used a chain)
- Glove

Optional
- Silicone or dimethicone
- Torch

STEP 1

Prepare your paints using a ratio of 1 part paint to 2 parts pouring medium. Slowly add water until the mixtures reach the consistency that you want. If you would like to add silicone or dimethicone, do so now, gently incorporating 1 or 2 drops into each paint color.

For this piece, I chose white, turquoise, and copper, with white as my base color and turquoise and copper to pull through the white. Choose a base color now, and feel free to use one or more colors on top.

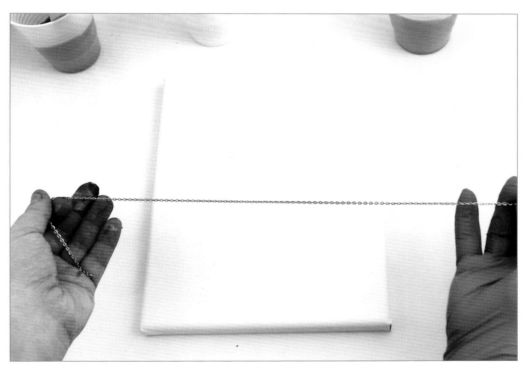

STEP 2

Rest your canvas on a flat surface. This technique does not require tilting the canvas, which is easier to do on cups, so I rested my canvas directly on a table.

Here is the type of chain I used for my chain pull.

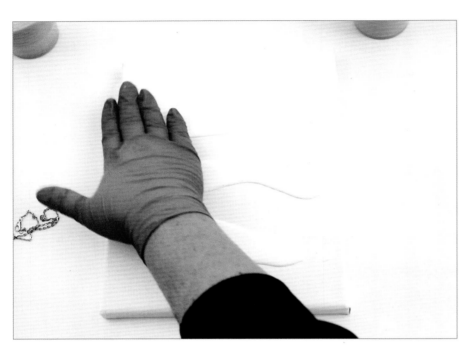

STEP 3

Put on your glove and spread a thin layer of base color over the canvas. I like to wear a glove instead of using a palette knife, as this allows me to feel how much paint I've spread over the surface of the canvas.

AVOID ADDING TOO MUCH BASE PAINT TO THE CANVAS. IF THE BOTTOM COAT IS TOO THICK, THE CHAIN OR STRING MAY SINK, AS WILL THE COLORS THAT YOU PULL THROUGH. THIS WILL RESULT IN A LESS-VISIBLE DESIGN.

STEP 4

Dip your chain or string into one of your other paint colors.

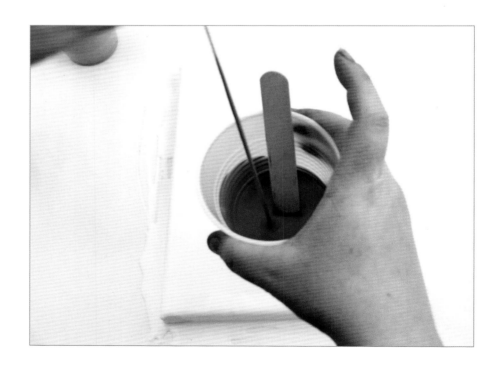

STEP 5

Place your chain or string on top of the canvas. If you wish to create a flower design, as I've done, place the chain or string in a snake or S-shaped design.

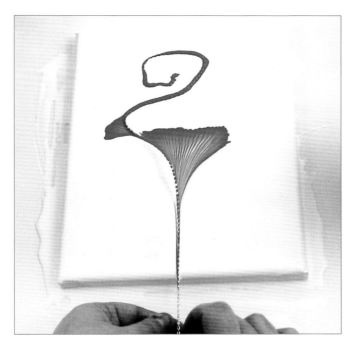

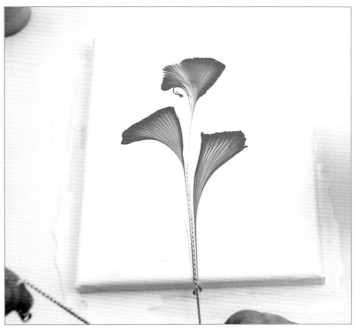

STEP 6

With a downward motion, gently pull the chain off the canvas. You will now start to see your design take shape.

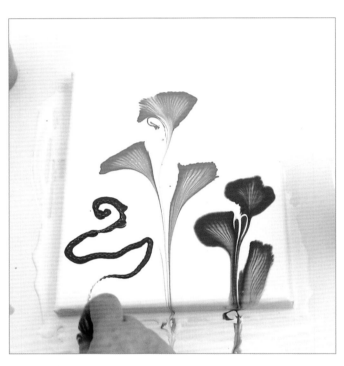 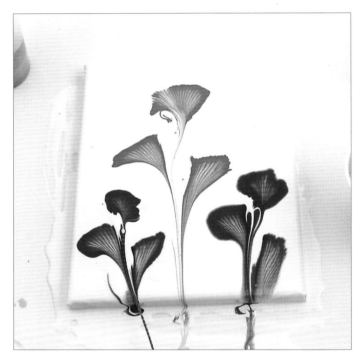

STEP 7

Rinse your chain if you plan to add another paint color to your piece.

Then repeat steps 4 through 6 using another color: Dip your chain into the paint cup, place the chain on the canvas, and slowly pull down. Then rest your canvas on a flat surface to dry.

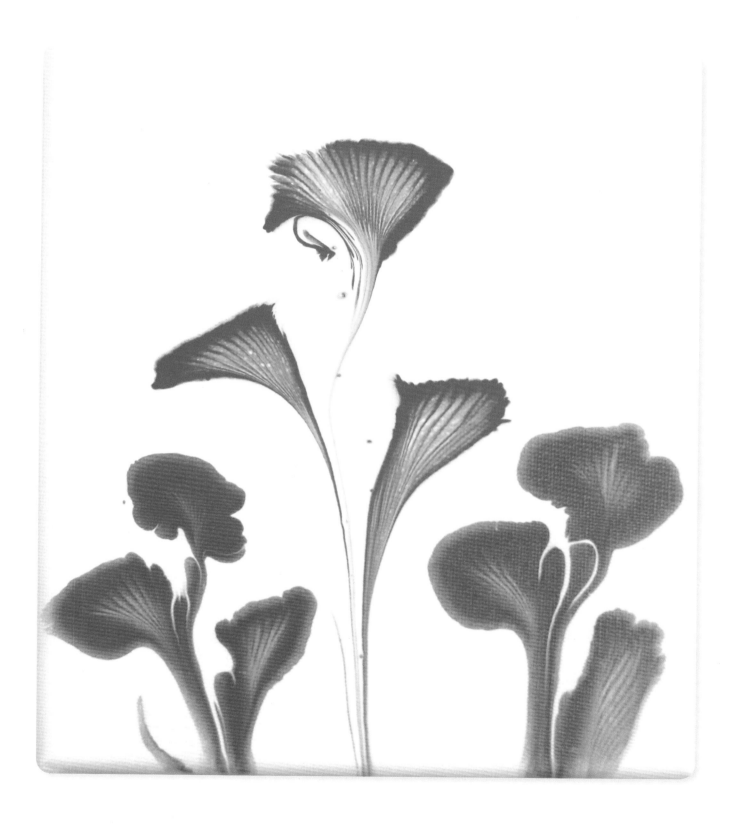

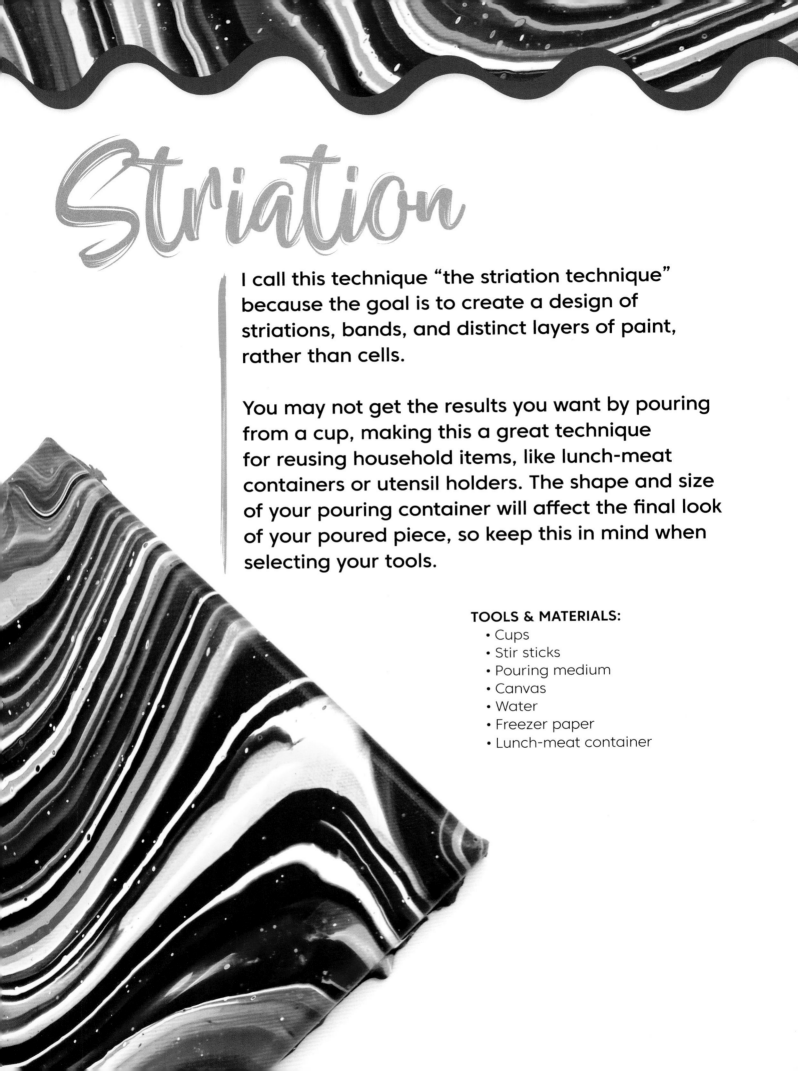

Striation

I call this technique "the striation technique" because the goal is to create a design of striations, bands, and distinct layers of paint, rather than cells.

You may not get the results you want by pouring from a cup, making this a great technique for reusing household items, like lunch-meat containers or utensil holders. The shape and size of your pouring container will affect the final look of your poured piece, so keep this in mind when selecting your tools.

TOOLS & MATERIALS:
- Cups
- Stir sticks
- Pouring medium
- Canvas
- Water
- Freezer paper
- Lunch-meat container

STEP 1

Prepare your paint. For this piece, I used gold, white, purple, and a light shade of peach, which I mixed using magenta, orange, and white.

Mix 1 part paint with 2 parts medium, and slowly incorporate water until the paint reaches the consistency that you want for pouring.

DO NOT ADD SILICONE TO YOUR PAINT MIXTURE; YOU WANT TO AVOID CREATING CELLS IN THIS PIECE.

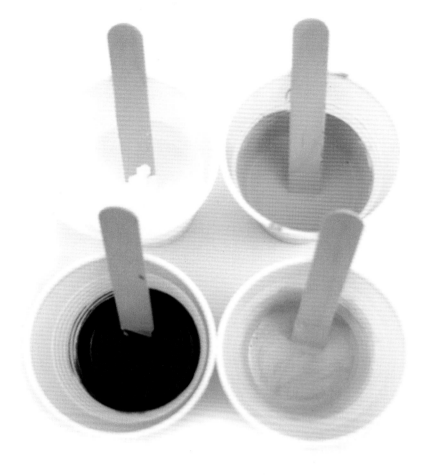

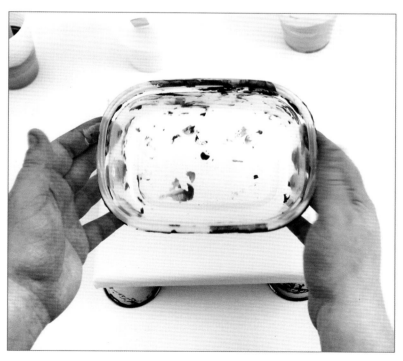

STEP 2

Place the freezer paper and cups on a flat surface, and rest your canvas on top of the cups. Here I've shown the style of lunch-meat container that I used.

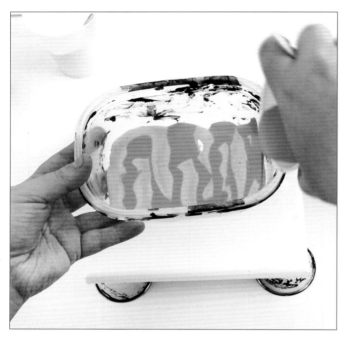 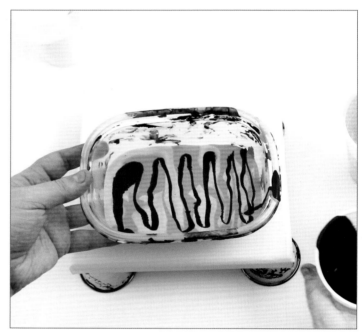

STEP 3
Pour the paints into your pouring container.

USING A STRIATED PATTERN WILL HELP CREATE THE DESIGN YOU WANT IN YOUR FINISHED PIECE; TRY USING A ZIG-ZAG OR UP-AND-DOWN MOTION AS YOU POUR.

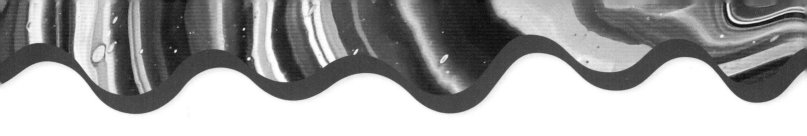

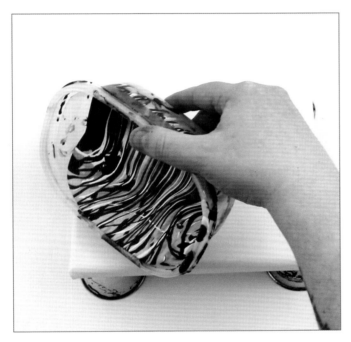 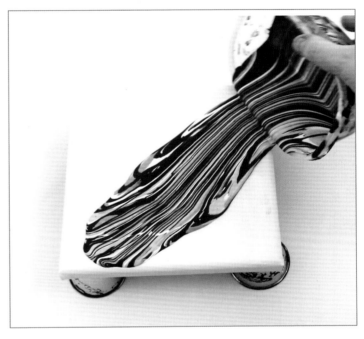

STEP 4
Pour your paint across the canvas, without pouring all of it into a single puddle, using a side-to-side motion.

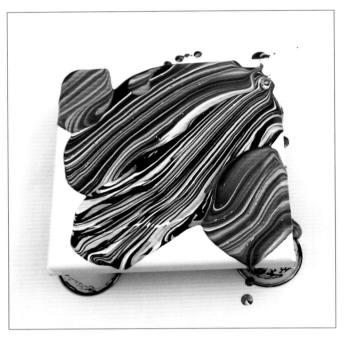

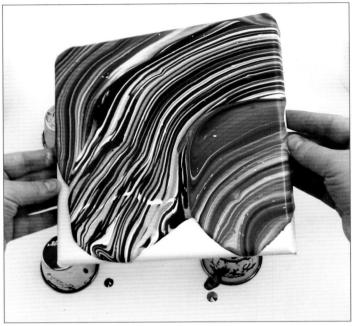

STEP 5
Now tilt the canvas in any direction you like. To avoid distorting the paint design, don't tilt the canvas too much; tilt it just enough to cover the entire canvas with paint.

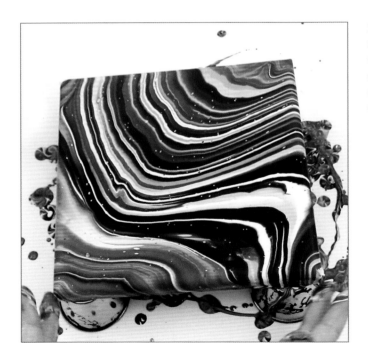

STEP 6
Use leftover paint to touch up the edges and corners of your canvas, and then lay the canvas on a flat surface to dry.

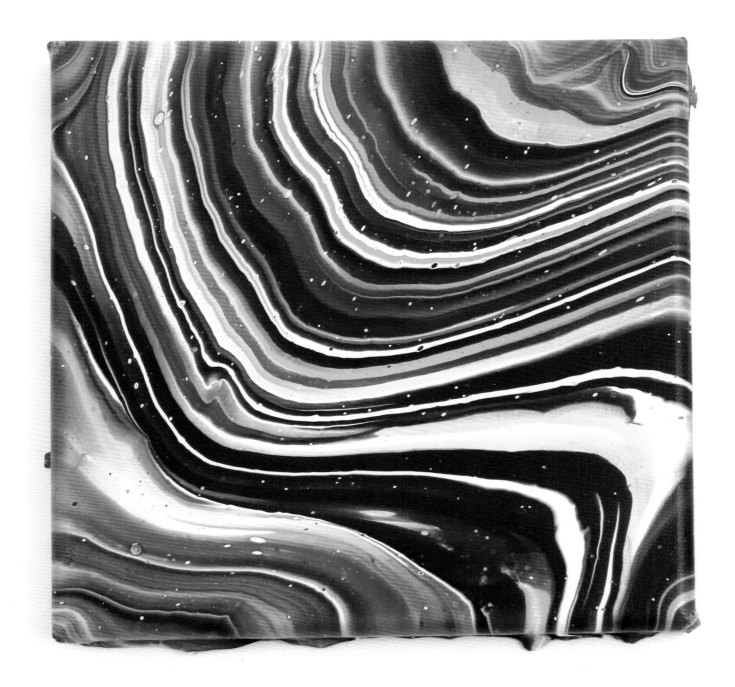

As you can see in my final piece, the lines of paint remain visible.
I only blended some areas and let the rest of the striations show,
which is exactly the look that I was hoping for!

Hammer

It's time to get messy! The hammer technique is new to me, but the more I try it, the more I enjoy it. It's done by pouring paint onto a canvas and then smashing the paint with a hammer to create abstract designs. As with the other techniques in this book, you can change up your design by trying different color palettes, adding silicone to the paint to create cells, and using a different type or size of hammer.

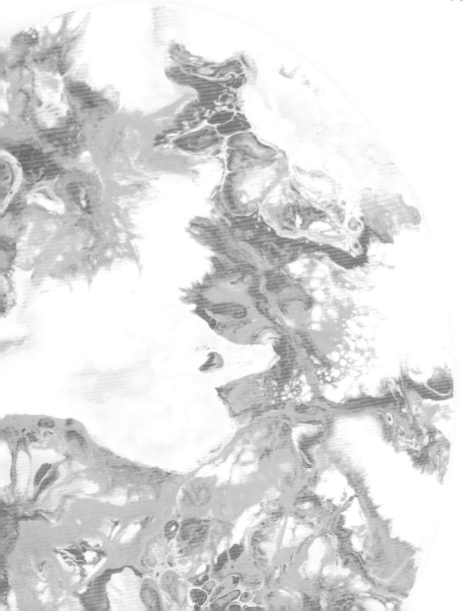

TOOLS & MATERIALS:
- Cups
- Stir sticks
- Pouring medium (I used Floetrol)
- Canvas
- Water
- Freezer paper
- Silicone or dimethicone
- Torch
- Hammer or mallet
- Palette knife

Optional
- Pipette

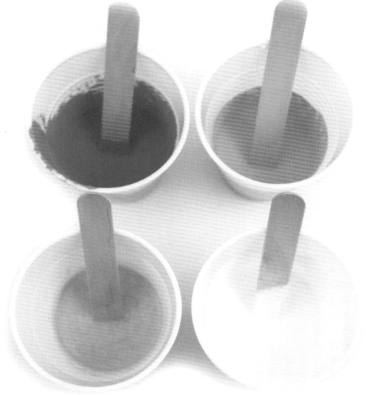

STEP 1

Prepare your paints. I chose gold, magenta, and white, and I created various shades of magenta by mixing in different amounts of white. I followed a paint-to-pouring-medium ratio of 1 to 2.

Then add water until your paint mixtures reach the consistency that you want for pouring. I also added 1 drop of silicone to each color.

STEP 2

You will hit your canvas with a hammer, so the canvas needs to be placed on a sturdy surface. I rested my canvas on a table covered with freezer paper instead of placing it on cups as I often do.

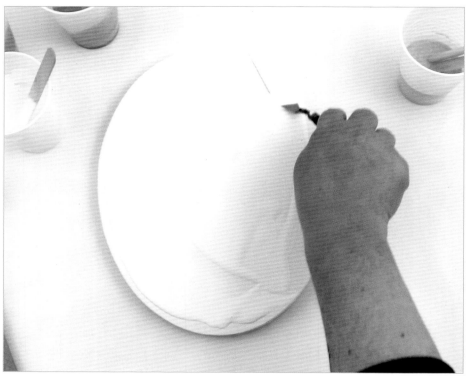

STEP 3

I started with a layer of white paint so that the colors on top would stand out against the background. I poured a small amount of white paint onto the canvas and then spread it using a palette knife.

FOR THIS TECHNIQUE, THE PAINT SHOULD BE POURED ONTO THE CANVAS IN SMALL PUDDLES. USING A PIPETTE TO POUR THE PAINT WILL GIVE YOU MORE CONTROL OVER THE AMOUNT OF PAINT YOU POUR.

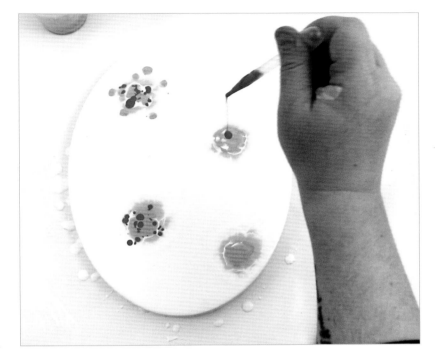

STEP 4
Using a pipette, add a variety of colors in puddles. Once you are happy with your puddles, use the hammer to hit the paint.

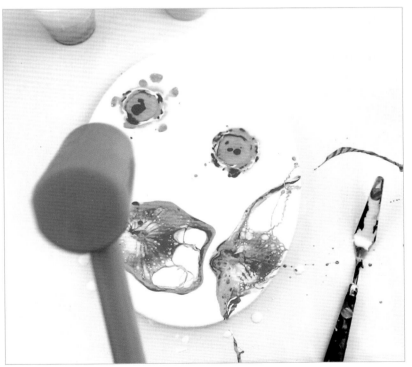

HITTING THE PAINT CAN BE MESSY, SO MAKE SURE YOUR WORKING SURFACE IS COVERED, OR KEEP DAMP PAPER TOWELS ON HAND TO CLEAN UP SPLATTERS.

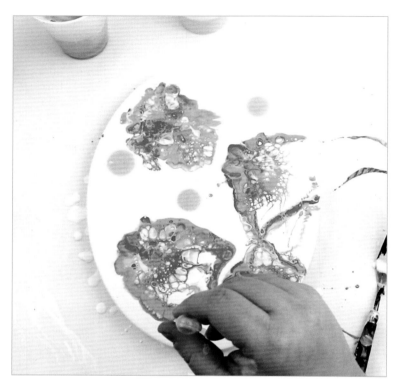

STEP 5

If you'd like to add more paint to your canvas, repeat step 4 until you're happy with your pattern. If you added silicone to your paint mixtures, torch the puddles now.

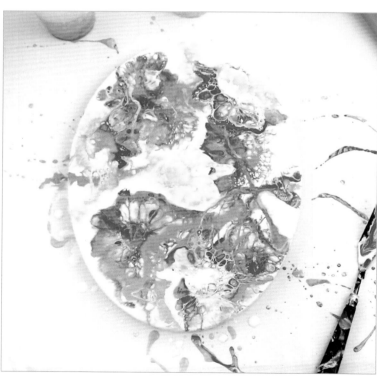

STEP 6

If you're happy with your design, rest the canvas on a flat surface to let it dry. However, if there's too much paint on your surface or you don't like the design you've created, tilt your canvas.

Negative Space

To create negative space in your poured artwork, you will use a single color for the background and then pour more colors on top. This allows the poured colors to really pop against the background.

I often use this technique. When I first tried it, I mainly used black and white as my background colors. As I've gotten more comfortable with color palettes, I like to use other colors in my backgrounds, such as blue or gold.

TOOLS & MATERIALS:
- Cups
- Stir sticks
- Pouring medium (I used Floetrol)
- Wooden circle (a canvas will also work)
- Water
- Freezer paper

Optional tools for creating cells:
- Silicone or dimethicone
- Torch

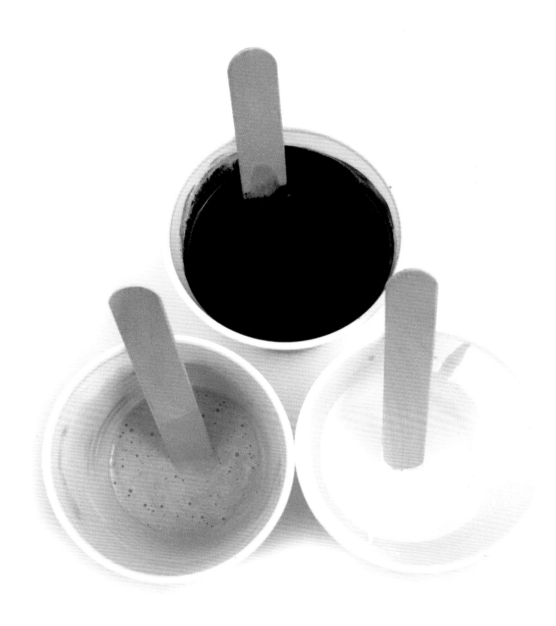

STEP 1

Prepare your paints using a ratio of about 1 part paint to 2 parts pouring medium. Then slowly incorporate water until your mixtures reach the right consistency. I chose black as my background/negative space color, with white and gold as the pouring colors.

STEP 2
Use a palette knife to evenly spread your background color over the wooden circle.

WHEN WORKING ON A PAINTING, YOU CAN MIX UP MORE PAINT THAN YOU NEED, AND THEN SAVE THE LEFTOVER PAINT FOR OTHER PROJECTS, INCLUDING COASTERS.

STEP 3

Use any pouring style you like in this project. I used the dirty pour technique (see pages 38-43) and poured just a small amount of black into my cup, and then more of the white and gold paints.

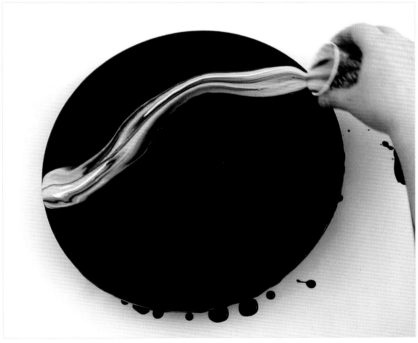

STEP 4

Pour your paint!

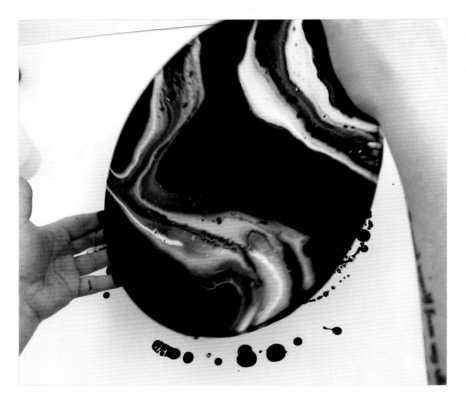

STEP 5
Tilt the wooden piece until you are happy with your design.

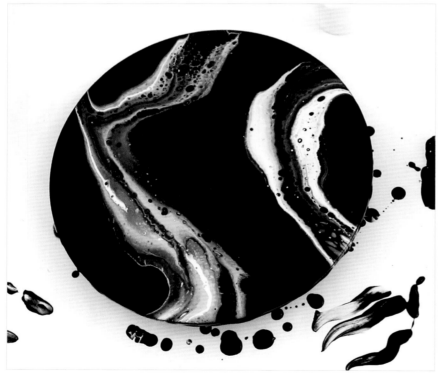

STEP 6
Touch up the sides and edges of your piece, and lay it flat to dry.

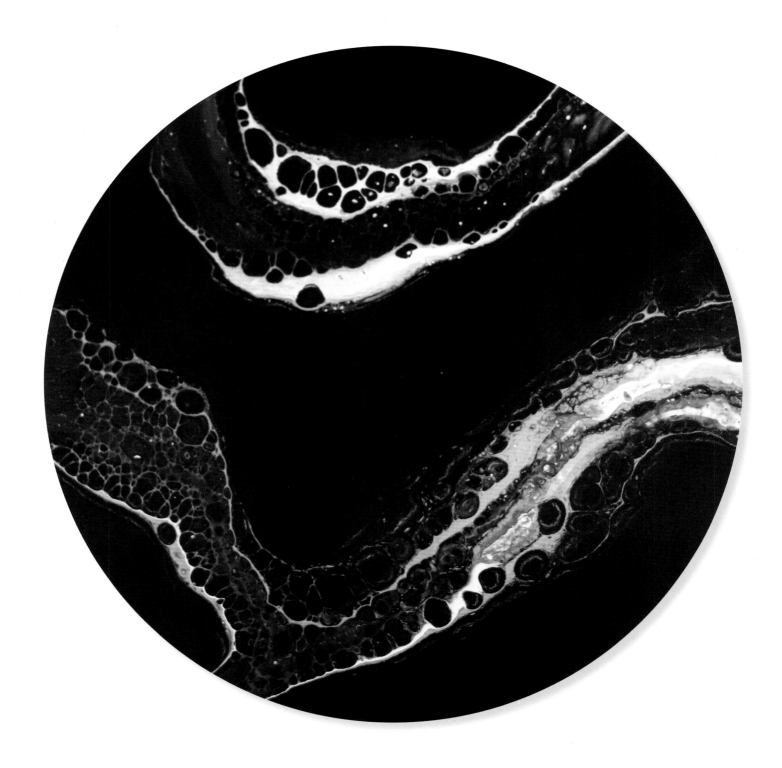

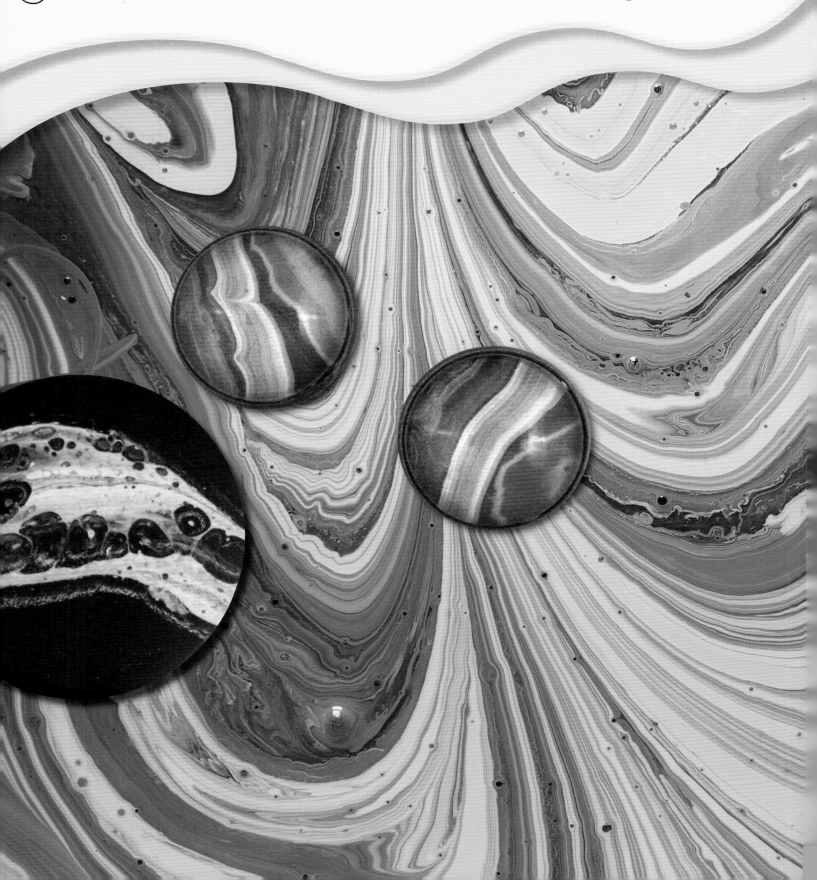

Alternative Surfaces

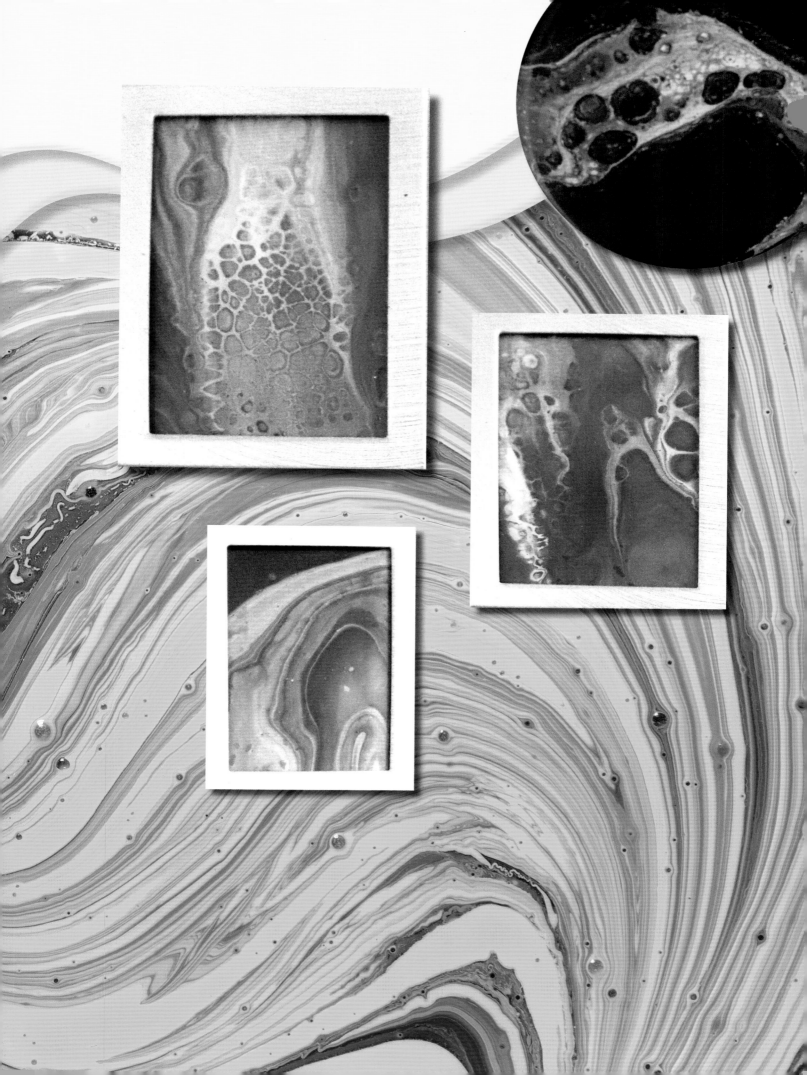

Jewelry

I use leftover skins from poured paintings to make pendants, necklaces, earrings, and bracelets. The amount of detail you can create in these small pieces is amazing, and with blank pendant trays and glass cabochons, the possibilities are endless.

I buy my jewelry-making supplies online, but they can also be purchased in craft stores. The basic supplies you will need include glass domes, also known as cabochons; blank pendant trays; and jewelry glue. I use two kinds of glue: one to glue the skin to the glass, and another to glue the acrylic skin and glass piece into the tray.

TOOLS & MATERIALS:
- Glass cabochons
- Pendant trays
- Jewelry glue
- Clear craft adhesive glue (such as E6000)
- Acrylic skins (see pages 34-35)
- Scissors

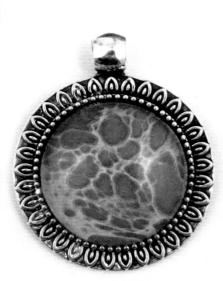
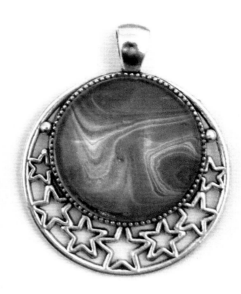

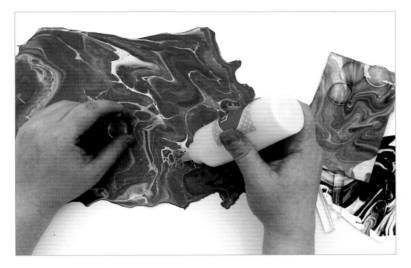

STEP 1

There are two ways to begin this process: You can cut out the acrylic skin and glue it to the glass, or glue the glass to the skin and then cut around the shape once dry. I prefer the latter way.

Move the glass cabochon over the acrylic skin to find the area that you'd like to use in your piece of jewelry. Then use jewelry glue to glue the glass piece to the acrylic skin.

USE GLUE SPECIFICALLY MADE FOR JEWELRY, AS IT DRIES CLEAR WITHOUT YELLOWING.

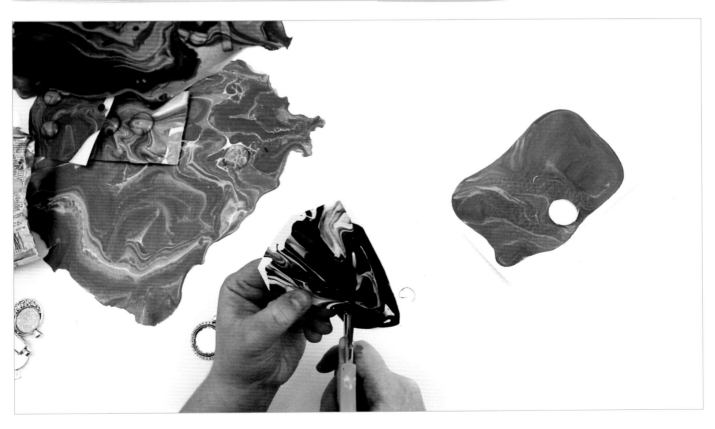

STEP 2

Let the glue dry for at least 24 hours. Then cut the glass piece from the acrylic skin.

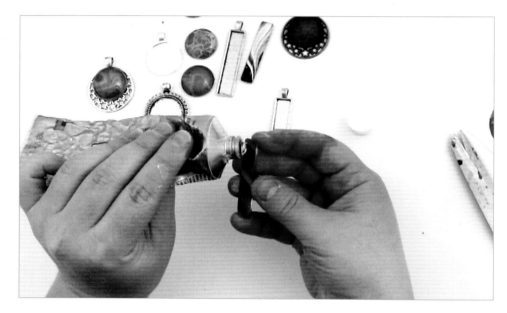

STEP 3

Add glue to the pendant tray or to the back of the glued skin and glass piece, and rest the piece in the pendant tray. Press firmly to adhere the glue. If you add too much glue and it pours out on the sides, use a tissue or piece of paper towel to wipe away the excess.

TO GLUE THIS PIECE INTO THE PENDANT TRAY, USE E6000. THIS STRONG, PERMANENT ADHESIVE CAN BE FOUND IN ANY CRAFT OR HOME-IMPROVEMENT STORE, AND ONLINE.

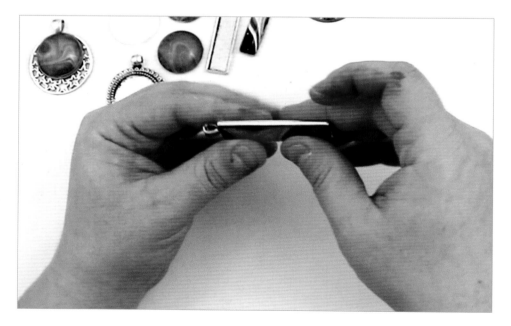

STEP 4

Let the piece dry for at least 24 hours.

Here you can see the piece created for this project (on the left), as well as a few other ideas for jewelry made from poured art pieces.

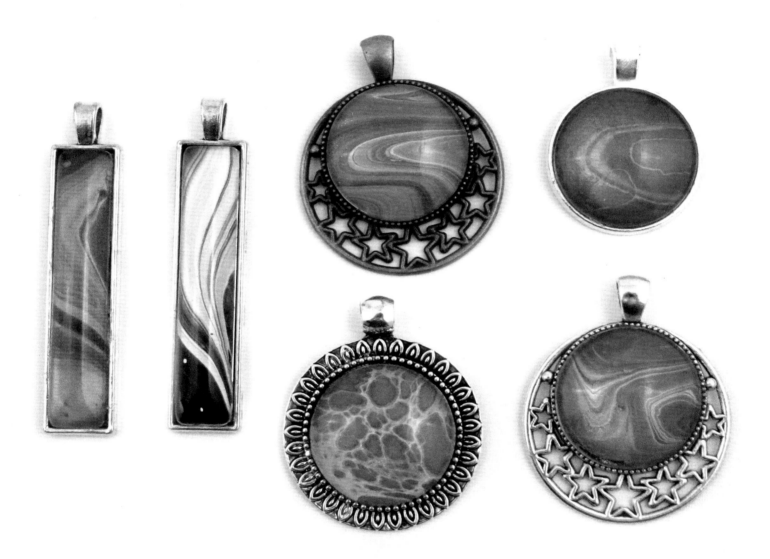

Seasonal Items

Your poured artwork can also be transformed into seasonal items, such as Christmas ornaments. When the weather is nice, I like to paint on terra-cotta pots. Both items make great decorations for the home and holidays, so let's explore painting on these surfaces, starting with clay pots.

TOOLS & MATERIALS:
- Pouring medium
- Water
- Cups
- Stir sticks
- Paintbrush

Clay pots:
- Terra-cotta pots in any size
- Varnish or waterproof sealant
- Tape

Ornaments:
- Glass or plastic ornaments
- Wooden dowels
- Foam pieces
- Varnish

CLAY POTS

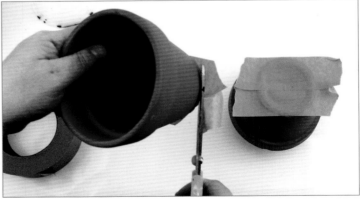

STEP 1
Apply tape to the bottom of the pots, trimming off any excess.

STEP 2
Place the pots upside down on cups to allow extra paint to drip off.

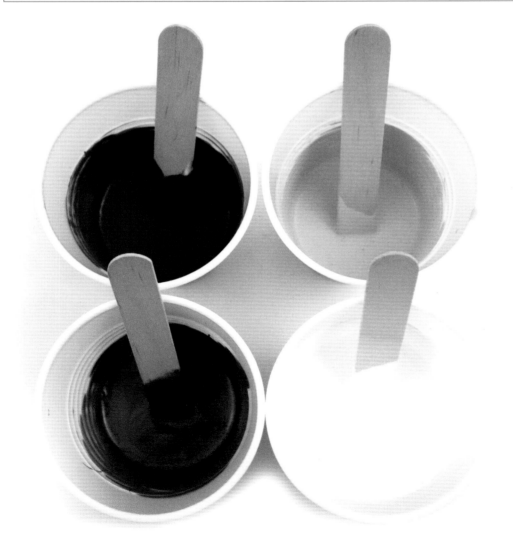

STEP 3
Prepare your paint mixtures. I used two shades of blue, metallic brown, and white, and a ratio of 2 parts pouring medium to 1 part paint. Incorporate the pouring medium, and then add water until the mixtures reach the consistency that you want for pouring.

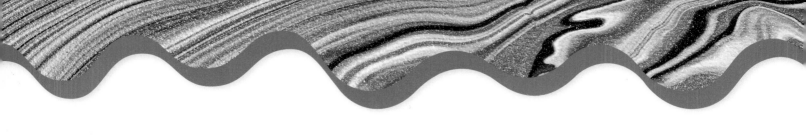

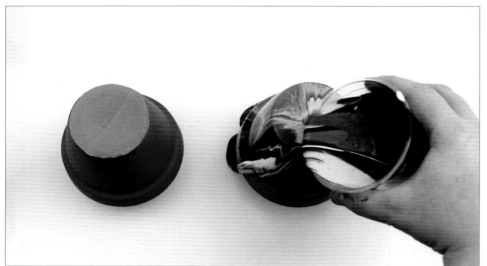

STEP 4

You can pour the colors individually, or use the dirty pour technique (see pages 38-43), as I did.

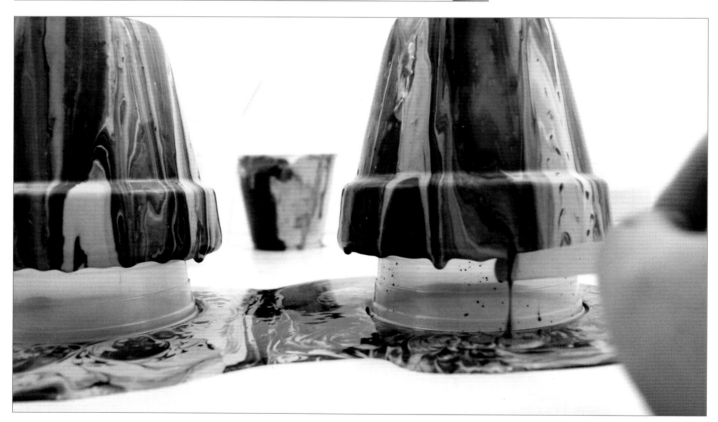

STEP 5

Use a stir stick or your finger to remove excess paint from the pot rims. Then let the pots dry for 24 to 48 hours.

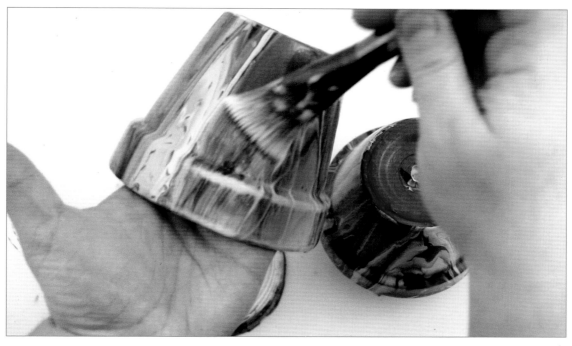

STEP 6

Once the pots are dry, remove the tape. If you plan to put plants in your pots, seal the insides and outsides now. If your plant pots aren't sealed, the water poured into them can create bubbles in the paint and ruin your work.

With a paintbrush, apply varnish, such as Sargent Art Gloss Medium, to the interiors and exteriors of the pots. This varnish dries waterproof.

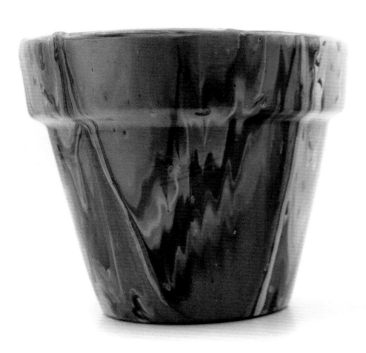

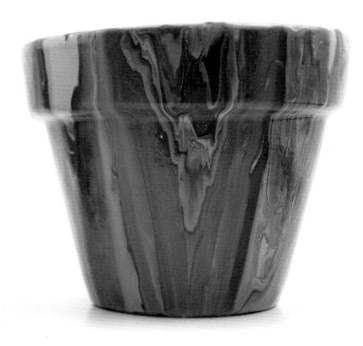

HOLIDAY ORNAMENTS

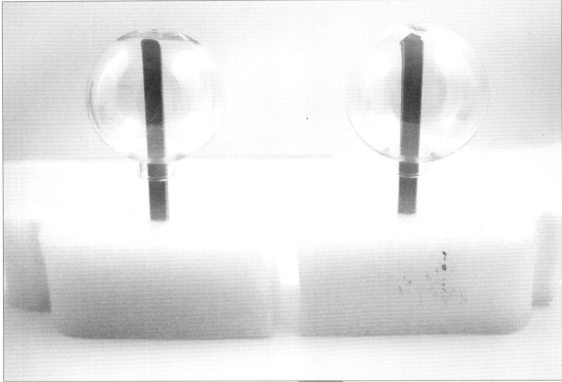

STEP 1
Place dowels in the foam pieces. Resting the ornaments on dowels will allow excess paint to drip off.

STEP 2
Prepare your paints. To create festive Christmas ornaments, I used red, green, and white, but any color combination would work.

Follow a ratio of about 2 parts pouring medium to 1 part paint. Add less water than you've done in the other projects, as you want your paint mixtures to be thicker here so that the paint will stick to the ornaments.

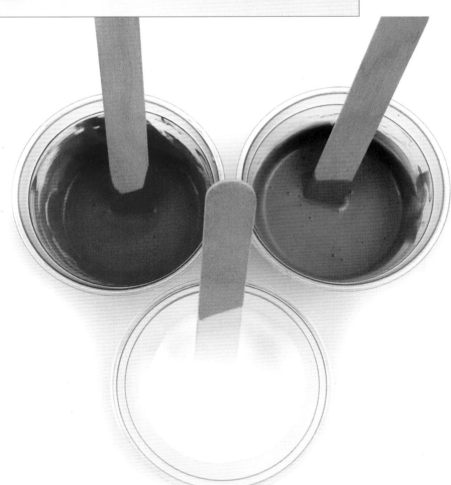

STEP 3

Pour your colors separately or use a dirty pour, as I did. Leave the ornaments on the dowels and let them dry for about 24 hours. Then use a paintbrush to apply liquid varnish.

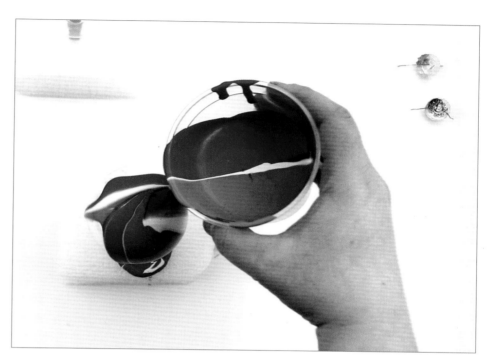

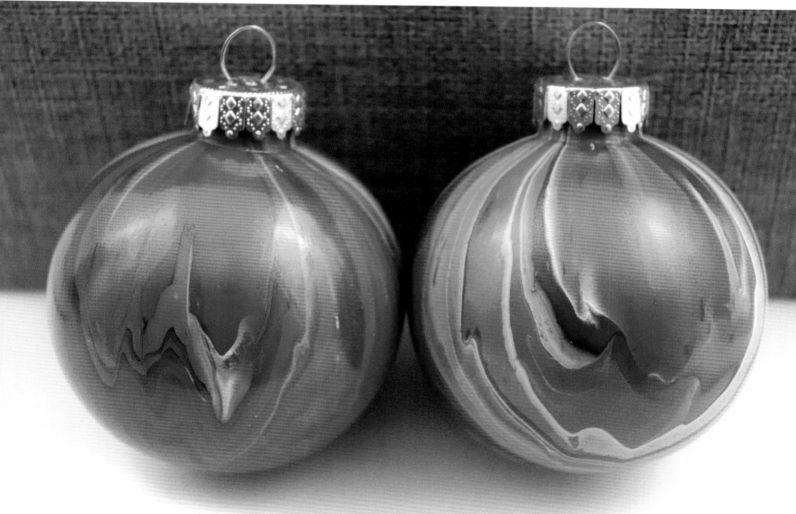

Bookmarks

Making bookmarks using poured art is a lot like making jewelry. I like to use blank bookmarks that contain pendant trays. These make great gifts for your favorite book lover!

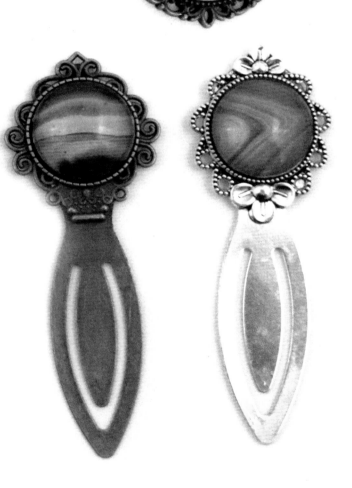

TOOLS & MATERIALS:
- Glass cabochons
- Acrylic skins
- Blank bookmark trays
- Jewelry glue
- E6000 glue
- Scissors

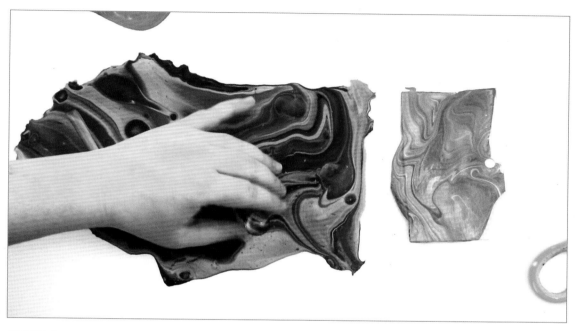

STEP 1

Place the glass cabochon on an acrylic skin. You can move around the glass cabochon to find the area of the skin that you want to use. Then glue the glass piece to the acrylic skin using jewelry glue.

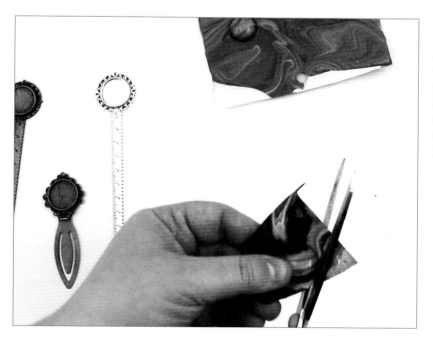

STEP 2

Let the glue dry for at least 24 hours. Then cut the glass piece out of the acrylic skin and glue the glass piece into the bookmark using E6000 glue.

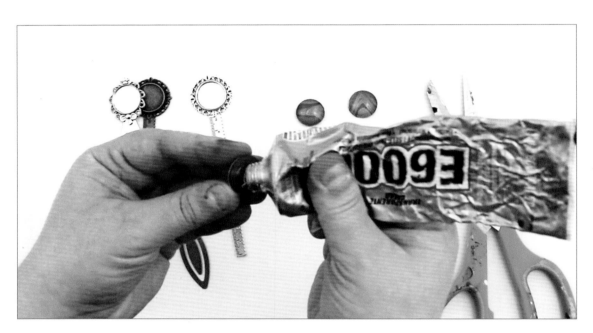

STEP 3

Pour glue directly into the pendant tray, or apply it to the back of the glued glass piece, and rest the glass piece in the pendant tray. Press firmly to adhere the glue. If you add too much glue and it spills out around the edges, use a tissue or piece of paper towel to wipe off the excess.

Then let your bookmarks dry for at least 24 hours.

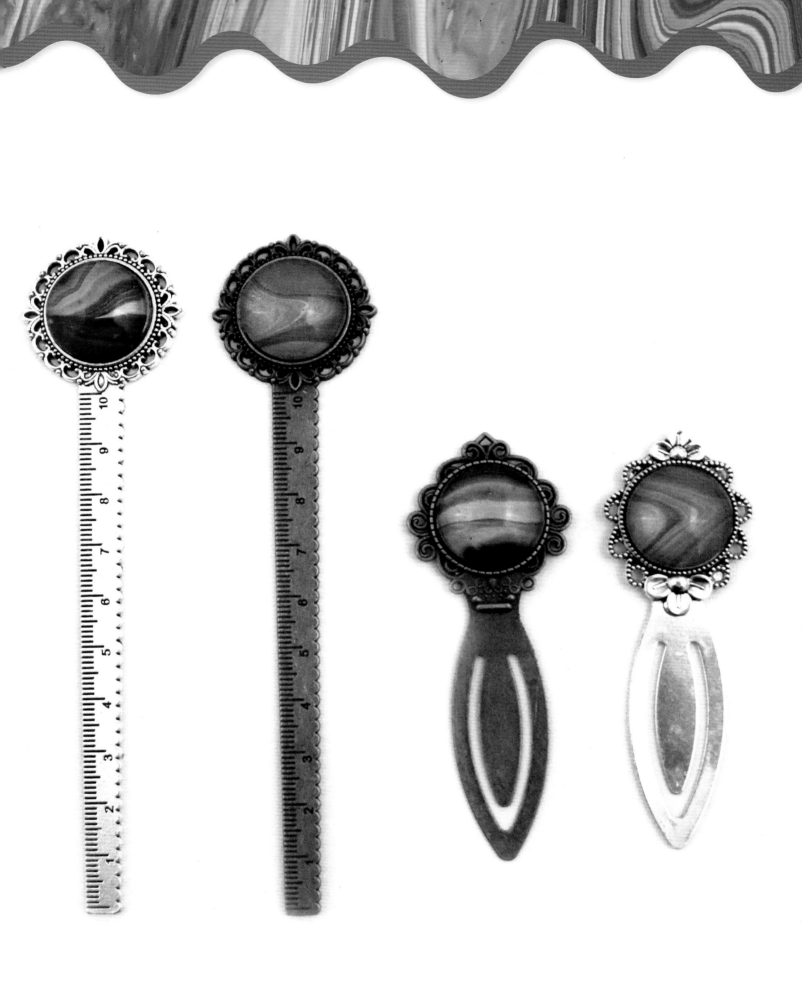

Coasters

While I enjoy making larger paintings, coasters are my favorite thing to create. They're smaller, but you can still achieve a lot of detail in your pieces, and each coaster serves as its own individual painting. I like to use 4-inch wooden circles, but squares or hexagons work as well. Another option is to use small ceramic tiles, found at home-improvement stores. Wooden circles and squares can be purchased online and in craft stores.

TOOLS & MATERIALS:
- Wooden circles
- Pouring medium
- Water
- Freezer paper
- Cups
- Stir sticks
- Tape
- Scissors
- Resin
- Gloves
- Respirator
- Torch
- Cork or felt
- Varnish or waterproof sealant

Optional tools for creating cells:
- Silicone or dimethicone
- Torch

STEP 1
Place freezer paper over your working surface and rest the wooden circles on top so that the excess paint can drip off.

TO KEEP YOUR WOODEN PIECES FROM WARPING, FIRST ADD GESSO OR PRIMER TO THEM.

STEP 2

For this project, I used the leftover black, gold, and white paints from my negative space painting (see pages 98-103). If you don't have any leftover paint, mix up a small batch now.

Use any pouring technique you like. I used the negative space technique and started with black paint, and then I added gold and white before tilting each coaster to create a design that I liked. Then rest the coasters on a flat surface to dry.

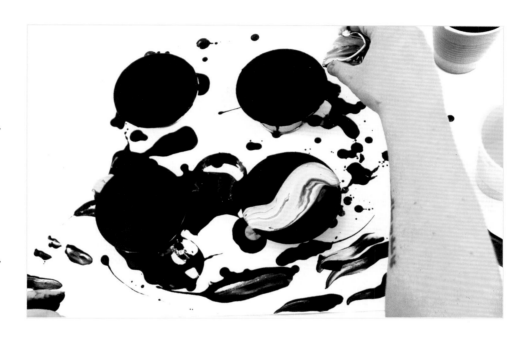

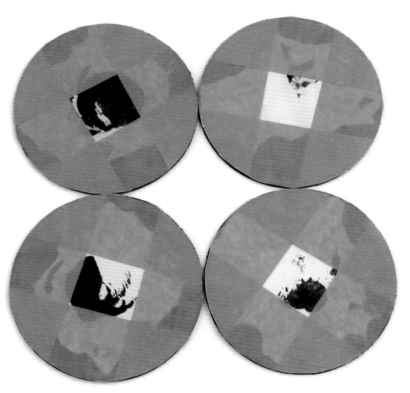

STEP 3

Let the coasters dry for at least two weeks. If you add resin too soon, moisture can cause the resin to become cloudy.

Place tape on the back of each coaster so that you can easily remove the resin drips once dry.

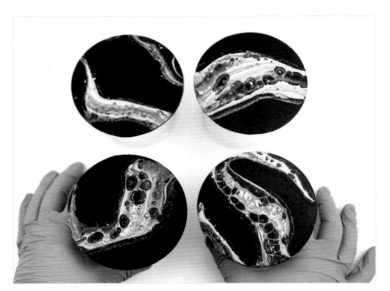

STEP 4

Place freezer paper over your working surface, and rest the coasters on cups.

Before using and mixing resin, read the safety instructions, and make sure to wear gloves and a respirator for protection from fumes.

The resin that I use recommends mixing for 3 minutes. Don't worry if you see air bubbles; torching the coasters will remove them.

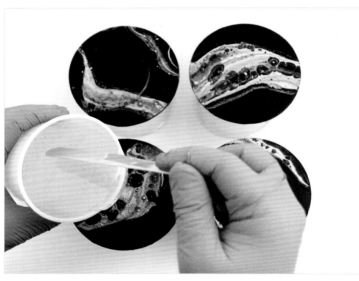

STEP 5

Use a gloved hand or stir stick to evenly spread the resin over each coaster, including its sides. For even coverage, you may need to apply two or three coats of resin. Wait 12 hours between each coat. Then apply a torch over each coaster to remove any air bubbles.

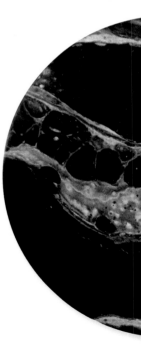

STEP 6

Wait at least a week before finishing the back of each of each coaster. Then remove the tape and any resin drips.

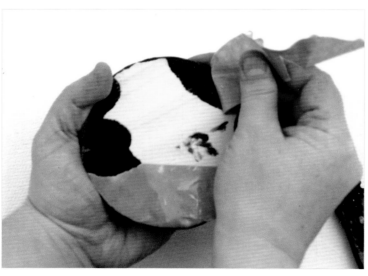

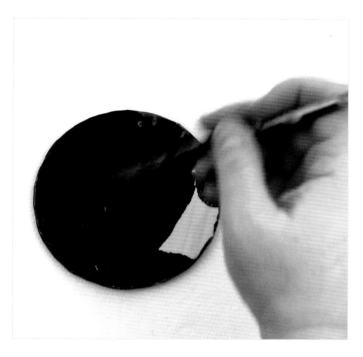

STEP 7

Paint the back of each coaster with a color that matches the front, and then apply a waterproof varnish or sealant once the paint is dry.

STEP 8

Once the varnish is dry, add cork or felt to the back of each coaster. I buy cork online, and it comes with adhesive backing. You can also use glue to adhere cork or felt to the backs of your coasters.

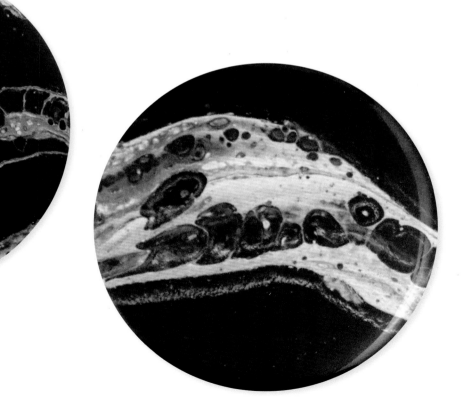

Magnets

I make magnets in two ways. Both are extremely simple and create great little pieces to give as presents or showcase on the refrigerator. The first method I'll show you uses small magnetic frames, and the second way is similar to my process for making jewelry.

TOOLS & MATERIALS:
- Miniature frames with magnets on the back
- Acrylic skins
- Glass cabochons
- Pendant trays
- Jewelry glue
- E6000 glue
- Scissors

MINIATURE FRAMED MAGNETS

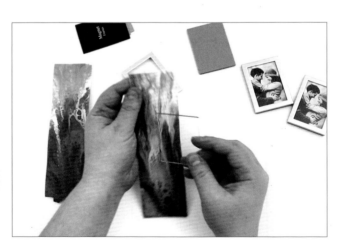

STEP 1
Remove the back of the frame and take out any inserts. Use the glass piece or an insert to measure the size of acrylic skin you will need.